Published © 1998 *by*
Booth-Clibborn Editions
12 Percy Street
London W1P 9FB
in conjunction with:
Candy Records
249-251 Kensal Road
London W10 5DB

Book: ©1998 Booth-Clibborn Editions / Candy Records
Except for original contributions, copyright for which rests with the writer, artist, designer or photographer
CD: ℗1998 Candy Records unless otherwise stated (see box credits)

Authors: @mbassadors in the earthly guise of Martin Sexton & Paul Hitchman
Music Executive Producers: @mbassadors
Designed by 'The Carpet Gypsies' ©1998
Structual concept by @mbassadors
Frame work plus textual sequences: '@ambassadors', 'In the beginning', 'Coming attractions', 'Vision,' 'How to get in touch with the @mbassadors', 'Radical chic',
'Beckett', 'The hypocrite', 'Look at the cocks', 'Trophy Art', 'Secret Histories', ©Martin Sexton • 'Love intoxication', ©Paul Hitchman • 'Traitors gallery', 'Joyce',
'Casino econmics, mesmerisation and the harmony of numbers' ©Sexton/Hitchman.

Copyright text : 'Master of the universe' ©Aidan Walsh • 'Invocation', 'Mantra of the awoken powers', 'Minimalist history of the @mbassadors' ©Sex W Johnston
• 'Barry's Faxes' ©Barry Flanagan • 'High concept' ©Don Simpson • 'London New York Interview' ©Sexton, Hitchman, Holman & Taylor • 'Una Serata con
L'Abascitori Di Musica' ©Umberto Primo, Sexton, Hitchman • 'Return of the 'Society of the spectacle' ©Guy Debord • 'Groovy, groovy' ©Jessica Voorsanger •
'Damaged Nature' ©Gustav Metzger • 'You gotta have lost a couple o' fights' ©Bono • 'High concept: Don Simpson and the Hollywood culture of excess'
©Charles Fleming • 'Fantasy Island' ©Tracey Emin • 'All about Love' ©Georgina Starr • 'Do you become disillusioned...' ©Andrew Wilson • 'Fat Sue' ©Leigh
Bowery ' • 'From the standpoint of the infinite' ©Rabbi Shnew Zalman • 'The celebrity...', 'The spectacle is...' ©Guy Debord • 'Who amongst us...' ©Graham
Greene • Syd Barrett, anecdote ©Jacques Peretti • 'The Fullness that Fills up the Pulse of Durations is Full' ©Chris OFILI • Hide dark ambassador...©Jean Cocteau.

Copyright artwork: 'The Ambassadors' ©Hans Holbein • Montages ©Richard Torry • 'Bloody Faith' ©Gilbert & George • 'Family tree', 'Peel the banana karma',
'Instant gratification', ©Milo Hennessy • 'Action painting' ©Duggie Fields • 'óọ (xxy)' © Marc Quinn • 'Macrohard' ©Sexton • 'The History of the World'
©Jeremy Deller • 'Summer Zephyr', 'Detroit', 'Artist's Studio' ©Rufus Knightwebb • 'The Davidsons' ©Ashley Bickerton • 'Gray photomontage' ©Holman
Taylor • 'Unauthorised David Cassidy' ©Jessica Voorsanger • 'Bum Negative', 'Pop' ©Gavin Turk • 'All about love' ©Georgina Starr • Operation Candy ©Niamh
• 'Normapaths', 'Hypnotic Suggestion' ©Jane & Louise Wilson • The Adoration of Captain Shit & the Legend of the Black Stars ©Chris OFILI • No2 ©Big
Bottom • 'Sex, Hugh, Barry, serpent illustration' ©Hugh Cornwell.

Photography credits: 'Self portrait', Sex W Johnson ©Aidan Walsh • 'Sex Mantra photograph' ©John Horsley • Flanagan/Cornwell photograph ©Aidan Walsh •
Leigh & Nicola Bowery photo ©Mike Owen • Richard photographs ©Alex Mark Hanson called Simon • Towering Inferno photograph © Murdo MacLeod
• 'Sam Taylor Wood/Neil Tennant' photo ©James Sanger • 'Big Bottom' photo ©Tommaso Corvi-Mora • Sir Winston Churchill ©Beresford • Samuel Beckett,
James Joyce ©Hulton Getty • Stefan Girardet ©Martin Avery • Sir Antony Blunt by Ned Evans, Burgess, Philby, Maclean ©PA News • Brian Sewell ©Solo
Syndication • Tracey Emin ©Tracey Emin • @mbassadors ©Aidan Walsh & Barry Flanagan • Syd Barrett © Hipgnosis.
Stills from film: 'Macrohard montage' ©Duncan Ward.

Every effort has been made to trace the owners of copyright material, and we trust that no copyright has been infringed. The publishers kindly request to hear from any copyright holders not here acknowledged.

The @mbassadors would like to thank:
Flan, Suzanne, Niamh, Phoebe, Jim, Raf, Sam, Marcel Duchamp, Lynn Morgan, Kerry, Boo, Muhammed Ali, John, Guy Debord, Hero Twins, Edward, Vicky,
Rachel, James, Toby, Luis Buñuel, Crispin & Martin, Andrew, Ollie, Sophie, Sushi, Terry-Thomas, Florence Gould, Umberto, Orphée, Archy & Mehitabel, Don
Marquis, Scott, Callaghan, The Rebel, Mike, Robert, Bryan, J.D. Salinger, NWA, Mitchell, Las Vegas, Michael, Baloo the Bear & Master of the Universe.

ISBN 1 86154 088 4

Distribution world-wide and by direct mail through
Internos Books
12 Percy Street
London W1P 9FB

info@internos.co.uk
www.booth-clibborn-editions.co.uk

Printed in Hong Kong

Dedicated to the One We Love

breath of gods, your stinking piss,

O Anti-Muse and sons of Dis,

We call upon your sterile heart

To bless our Fuck, to bless our ART.

'Invocation' • Sex W Johnston, *Ireland 1998*

IN THE B

EVERYT

VOID AND

FORM A

SERPE

LET TH

N O

GINNING

ING WAS

WITHOUT

ND THE

T SAID

ERE BE

TS ST

1
MINTY

'Useless Man'

1

2
SERPENTS
OF
THE
VORTEX

'Mantra of the Awoken Powers'

2

3
JESSICA
VOORSANGER
DUMB
ANGEL

'You're my Favourite Pop Star'

3

4
ASHLEY
BICKERTON
& GRAY

'The Mysterious Mister Bickerton!'

4

5
TRACEY
EMIN
BOY
GEORGE

'Burning Up'

5

6
TOWERING
INFERNO

'Crash'

6

7
GILBERT &
GEORGE
STEFAN
GIRARDET

'Bloodlines'

7

8
MACRO
HARD

'I Want to be Erected'

8

9
MAR
QUIN
BRIA
N

'Sensual Zero Gravity'

9

I G
OTTOM

11 ·
CHRIS
OFILI
ADD
N TO X

12 ·
RUFUS
KNIGHT
WEBB
DERRICK
MAY

13 ·
SAM
TAYLOR
WOOD

14 ·
DUGGIE
FIELDS

15 ·
JAKE
CHAPMAN
RUSSELL
HASWELL

16 ·
JANE &
LOUISE
WILSON
M 1 7

17 ·
GEORGINA
STARR

18 ·
GAVIN
TURK

'No – 2'

'The Fullness that Fills up the Pulse of Durations is Full.'

'Silent Revolution'

'Je t'aime ... moi non plus'

'Sometimes (Hey Now, Hey Now)'

'Digital Rim Smear Discharge: Solar Anus'

'Hypnotic Suggestion'

'All About Love'

'My Way'

10 11 12 13 14 15 16 17 18

V I S I O N

After a day of indulgence and a night of dreaming the @mbassadors awake, unglued from the looking glass, the now of r e f l e c t i o n

They exist beyond the curve of light, are infinite shadows of themselves, transcendent in s p a c e a n d t i m e

Like dusk and dawn, the sun at night, a thousand artists of the dead stand sentinel. A third says "Je suis Jarry-Anté Dieu" and continues "I am Alfred Jarry born on the feast of the Nativity of the Holy Virgin.... I am the keeper of the looking glass gateway between Anti God and God, the substance of the void-light. Now that you are transcendent of your bodies I charge you to take the 'anti-grail' upon the Earth and become the Heralds of Twenty-First Century Chaos-Culture. The grail waters are polluted and only the anti-grail can contain them"

We passed through the waters and the looking glass R e t u r n e d

@ M B A S S A D O R S

MBASSADORS

@mbassadors

MBASSADORS

@MBASSADOR

@mbassadors

2 • Serpents of the Vortex - *"Mantra of the Awoken Powers"*

Performed by Barry Flanagan & Hugh Cornwell

Lyrics by Sex W. Johnston

Music by Hugh Cornwell

Published by EMI Music Publishing / Copyright Control

Music and programmes by Hugh Cornwell

Additional programming by Lord G

Engineered and mixed by Lord G

Produced by H.A.C. for Sound Lab at Lord G's

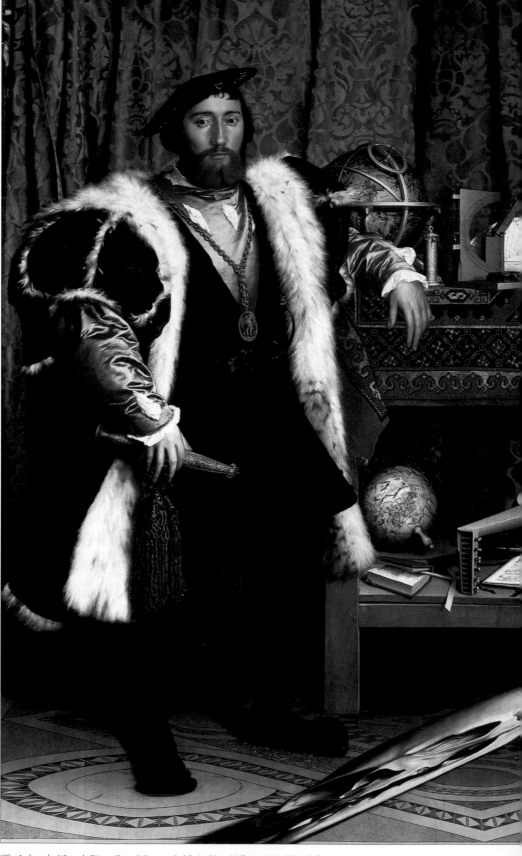

'The Ambassadors' (Jean de Dinteville and Georges de Selve) • Hans Holbein *1533. Oil on Oak*

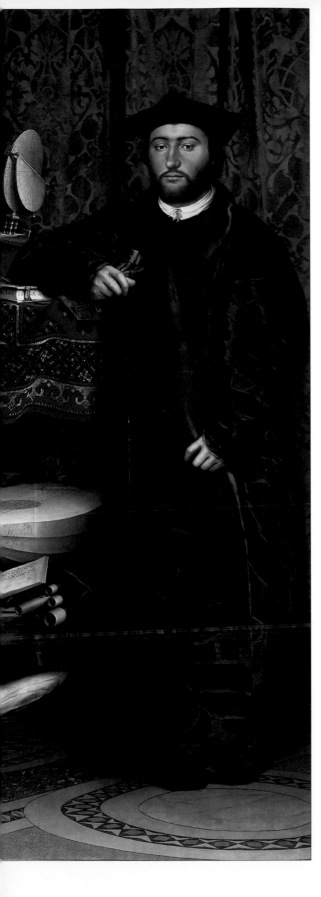

The @mbassadors receive the baton 1998. *Sonic Art Futique*

Master *of the* UNIVERSE *appoints the* @mbassadors

"I, Aidan Walsh, Master of the Universe, Emperor of the Eagles, hereby appoint the @mbassadors with full control over all the rubies & diamonds, acres of land & anything that works on the planet Earth (but not the different galaxies), you have full titles, everything, 'Rock your Brainy Head' trademarks to everything

Control me, promote me in every way you can. Make a big movie of me, not a small one a big one e

I am the Master, I am controlling everything, full power

@mbassadors you have no worries whatsoever"

'Self Portrait' • Aidan Walsh

'Pataphysics by region

- Middle East
- Africa
- Far East
- South and Central America
- South Asia
- rest of the world

'The 'Pataphysical World'

THE
'PATAPHYSICAL
WORLD

Electronic reconnaissance
USA 79 • EUROPE 125

Orion photographic reconnaissance
USA 235 • EUROPE 538 • ASIA 3

@mbassadors Interception-destruction-vortex
EUROPE 33

ARTWARS

'Artwars'

Geodesy
USA 19 • EUROPE 16 • ASIA 5

Magnum Ocean surveillance
USA 18 • EUROPE 32

Navigation
USA 39 • EUROPE 58 •ASIA 1

Early warning
USA 22 • EUROPE 366

Voicecast Communications
USA 118 • EUROPE 366 • ASIA 9

Mantra

Of The

Awo

Photo by • John Horsley *1997. Poem •* Sex W. Johnston.

en

Powers

in a copse of blackthorn he cut a stave
then went beside my heart where I never went
then saw the place I was in that I never saw
then heard the songs I sang that I never heard
then said the words I spoke that I never said
and by a rocky shore he trapped a fish
then came to the mind where I never came

then thought the thoughts I thought that I never thought
then made the promises I made that I never made
then broke the hearts I broke that I never broke
then kissed the lips I kissed that I never kissed
and in a bush of furze he caught a bird

then fell into the soul where I never fell
then killed the hope I killed that I never killed
then breathed the breath I breathed that I never breathed
then weaned the child I weaned that I never weaned

then lost the self I lost that I never lost
and in my hand I held a stave
and in my mouth I held a fish
and with my foot I held a bird
and I was alive though he was dead
and I moved though he was still

and I remain though he remaineth not

Feb, 21/98

In the early days of the Sunday Times
they published Pablo Casals Colour Supliment
in a special edition.
Memorably playing Elgar, also Song of the Birds.
The musical Establishment, enamoured of the
shrill tuning ignored Casals; and to this
day it is hard to forgive the persistent
editing of his natural emotive grunts. *

I THINK
SO →
(a courageous
regime !)
The Sunday Times had also published the Budist
Monks chanting, with the swirling sonics
precipitating North America Loft Music.
* Casal's playing is of all music from the Root,
every incident he reinvent, he listens to sounds.
The readings on the tape of SEX W. Johnson's Mantra of the
are recorded on a Fostex X14 on track 1, Awoken Power
when listening to side B through the earphones side A
played through backwards.
May I suggest you consider this also as a solo
as time goes back
& Forward.
 Best Wishes
 Barry

odd hearing

Is it merely a matter
 of taste
 (am I really Bombastic ??)
 Sarcastic ??)
 or has it been the
 the master can't
 play
 can't
 Draw,
Defensive Boundary's over stated :
 Barry

Feb 21/98

untimelyness
My grievous ~~fault~~ Mother
not to have expressed
how I go on
thereby carrying you
through your
Threshold
My loss.

Feb 21/98

♪

The stealy string of Menhuin
indicative of Westminster.
When it comes to interpretation
in Art there is no answer:
None, certainly not Jane
 Russel, nor any
That scoffing refrain Guru
 Phylystine
I never through buss over.
Sounds is Sounds
 𝄞 𝄢:

Feb 21/98

Its the strangest thing:
Labeling the tape
I became thourough
& covered technical
data along with 'Sony'
So you know what —
 it disappeared

♪

Then re-appeared
Best wishes

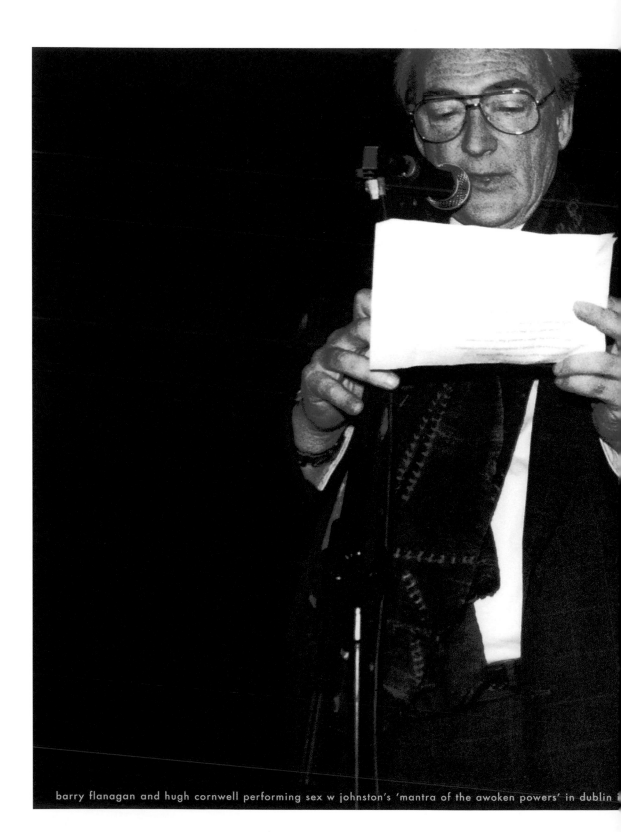

barry flanagan and hugh cornwell performing sex w johnston's 'mantra of the awoken powers' in dublin

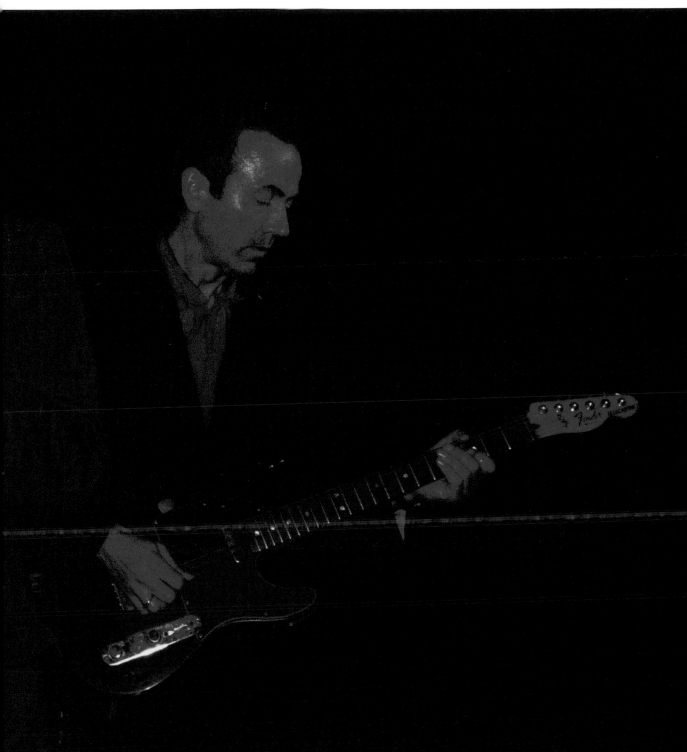

helan's bar saturday 2nd may 1998 • photographic image / witness master of the universe emperor of the eagles aidan walsh

Arse-licking, shit-stabbing,

mother-fucking, spunk-loving,

ball-busting, cock-sucking,

fist-fucking, lip-smacking,

thirst-quenching, cool-living,

e v e r - g i v i n g

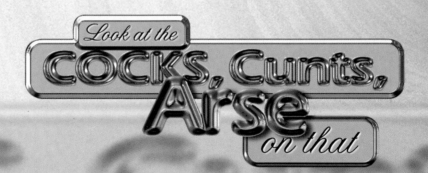

Look at the COCKS, Cunts, Ar'se on that

Look at the Cocks, Cunts, Arse on that

1 • Minty - *"Useless Man"*
Written by Leigh Bowery, Richard Torry, Ingo Vauk, Carl Fysh
(Copyright Control / BMG Music Publishing)
Mixed by The Grid at Eastcote Studios, London

7 • Gilbert & George / Stefan Girardet - *"Bloodlines"*
Performed by Stefan Girardet with Gilbert & George
Music and vocal arrangement by Stefan Girardet
Words by Gilbert & George
(Warner Chappell Music Publishing / Copyright Control)
Arranged and Produced by Stefan Girardet
Mixed by Stefan Girardet and Jon Pendleton
Keyboards, Programming, Loops & Guitar : Stefan Girardet
Voices: Gilbert & George
Drums Tim Weller
Feedback Guitar: Adam Blake
Solo Violin Adonis Alvanis:
Solo Cello: Zoe Martlew
Bowed Vibraphone: Chris Brannik
Recording Engineers: Danny Sykes *(Hoxton Studios)* Rowan Stigner *(Matrix Studios)*

14 • Duggie Fields - *"Sometimes (Hey Now, Hey Now)"*
Written by Duggie Fields
(Copyright Control)
Produced by Arthur Baker in New York and London

15 • Jake Chapman & Russell Haswell -
"Digital Rim Smear Discharge: Solar Anus"
Backwards edit remix
Written by Jake Chapman & Russell Haswell
(Copyright Control)
thanx: Berwick Street Studios, Paul Kendal
PLAY AT MAXIMUM VOLUME

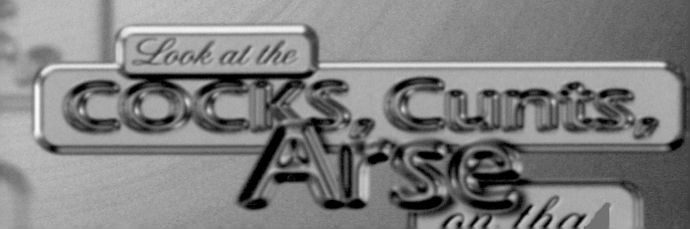

Look at the
COCKS, Cunts,
Arse
on that

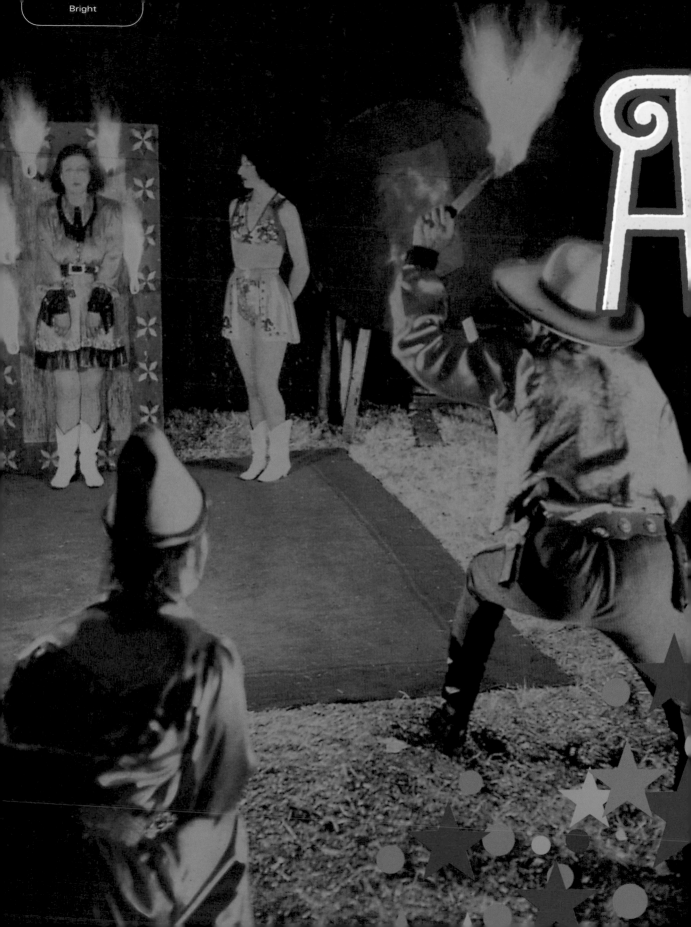

Coming Attractions

See the Man giving birth

See the Transmogrified twins

See Emily play

Peel the Bananakarma

Ego go E

Leigh & Nicola Bowery • *Photo by* Mike Owen

Sun!

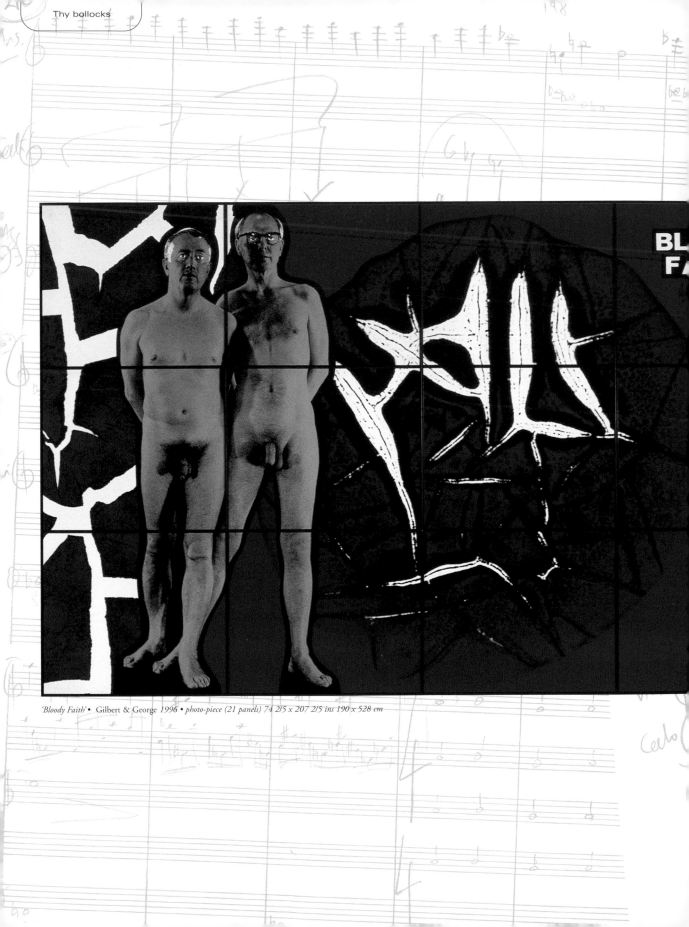

'Bloody Faith' • Gilbert & George 1996 • *photo-piece (21 panels) 74 2/5 x 207 2/5 ins 190 x 528 cm*

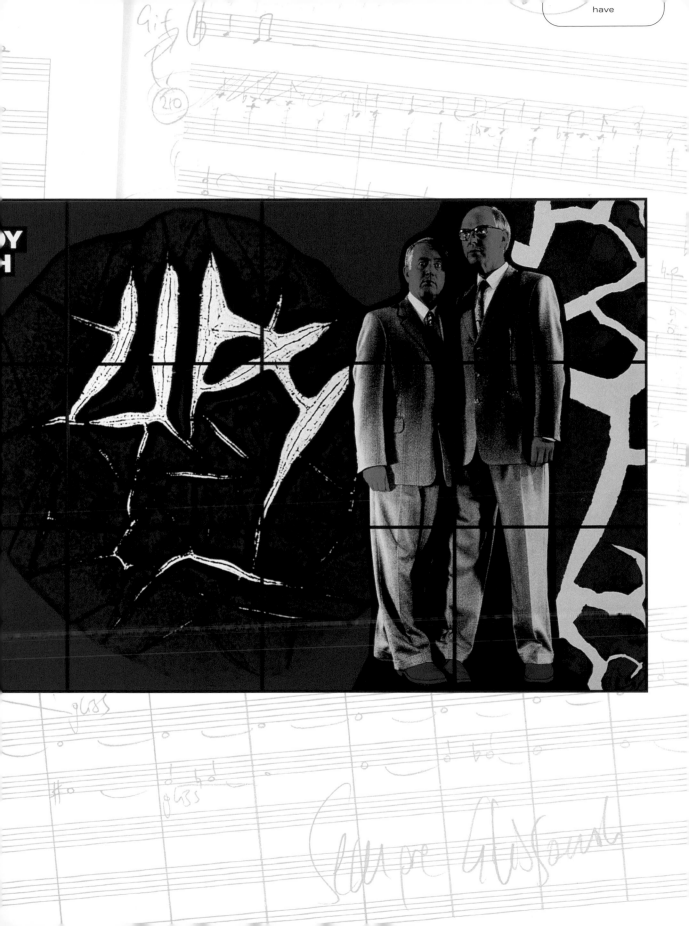

'Action Painting' • Duggie Fields

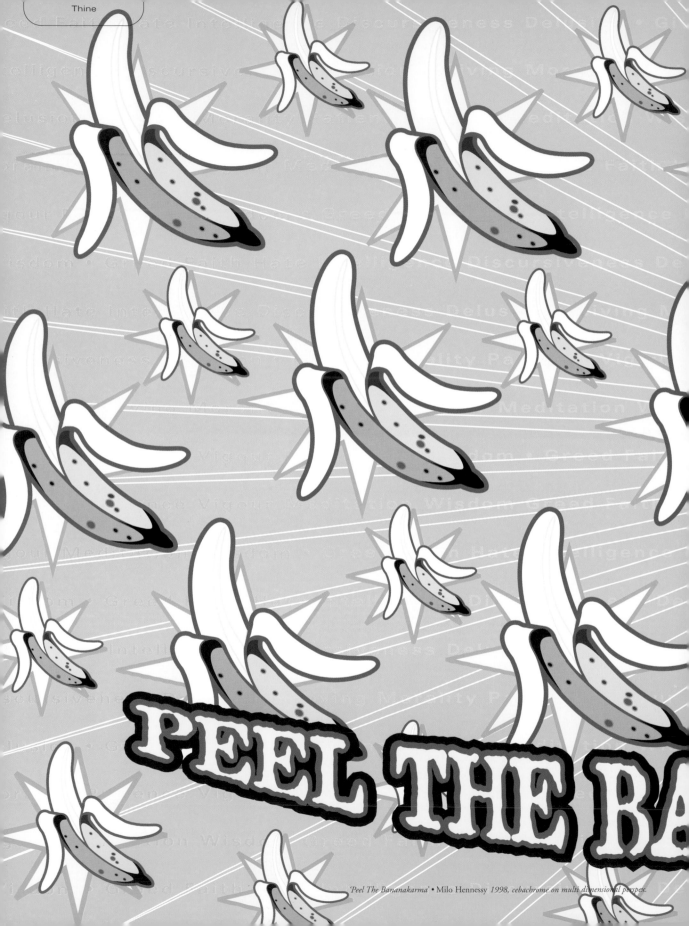

Thine

'Peel The Bananakarma' • Milo Hennessy 1998, cebachrome on multi dimensional perspex.

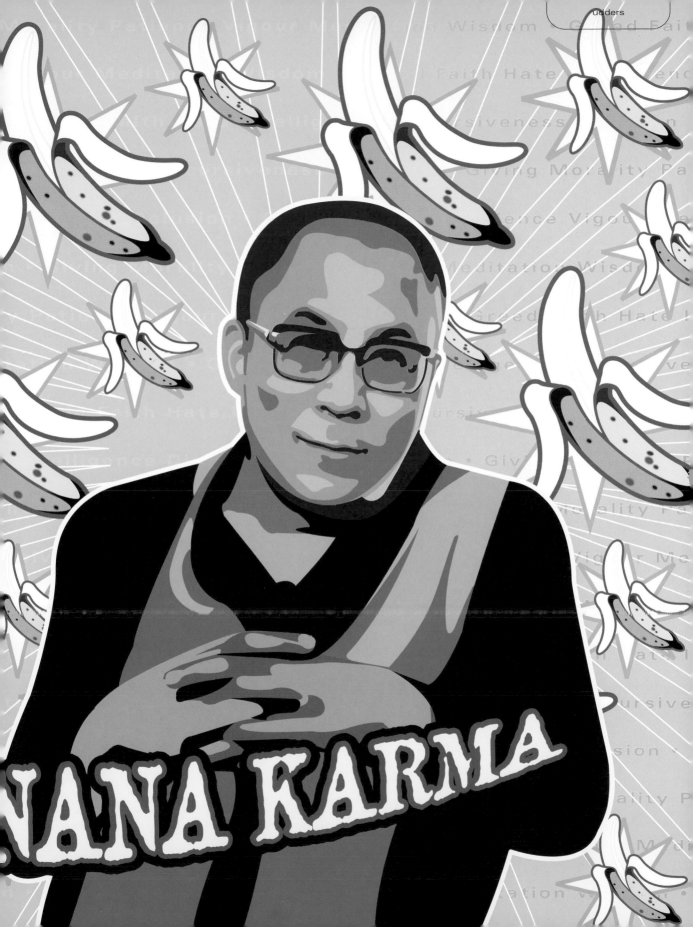

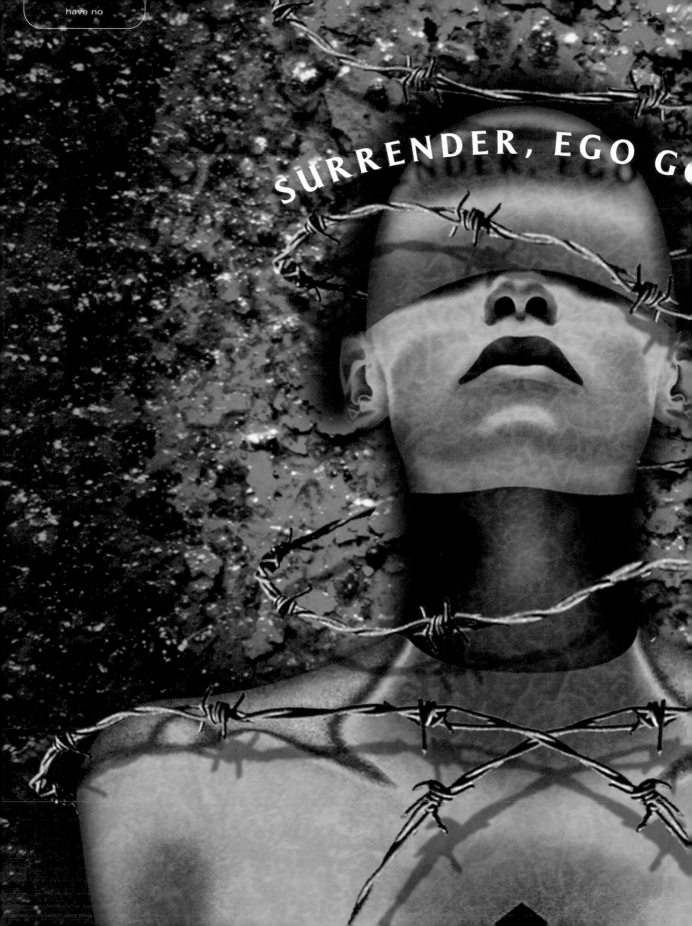

have no

SURRENDER, EGO G

'Surrender Ego Go E'

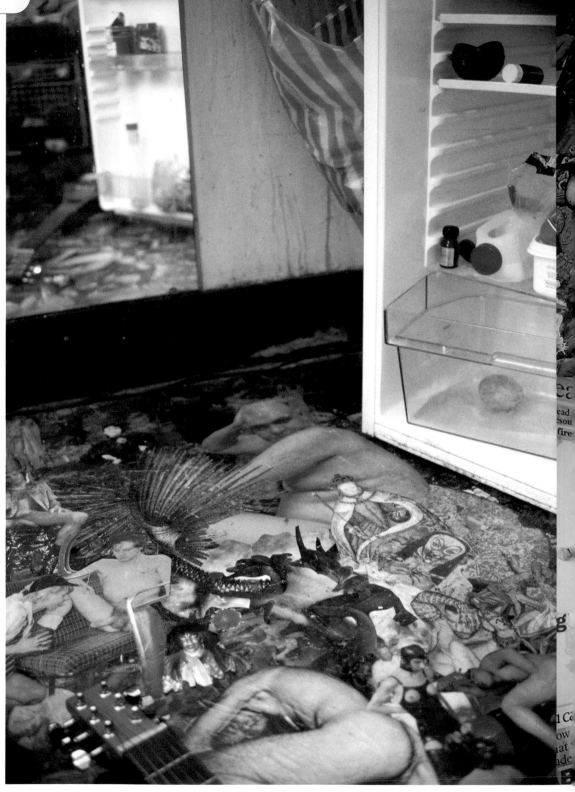

'Fat Sue, naked and red faced, lying on a

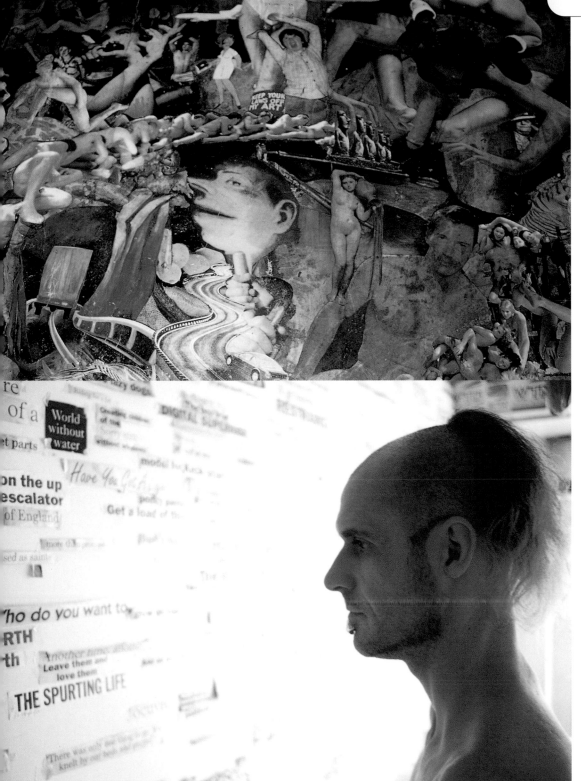

k chair, sniffing Poppers'. Leigh Bowery *visual concept for 'Useless Man'*

Montages by Richard Torry of 'Minty' • *Witness* Alex Mark Hanson called Simon

Even though the darkness is still unrelieved the eclipse is beginning to pass

The moment has come for conflict, for the cause is good, and the judgement of an impartial man will bring great fortune

To engage in conflict before a just judge brings supreme success

Abundance means great success: the greatness of the @mbassadors is an inspiration. Do not be downhearted, for the bright sun is at its zenith

Rich Kids, Nepotism
& Who You Know

With

£100

Bank of En

PROMISE TO PAY THE BEARER ON DEMAN

London

BANK of ENGLAND

'Family Tree' • Milo Hennessy *1998, cebachrome on multi dimensional perspex*

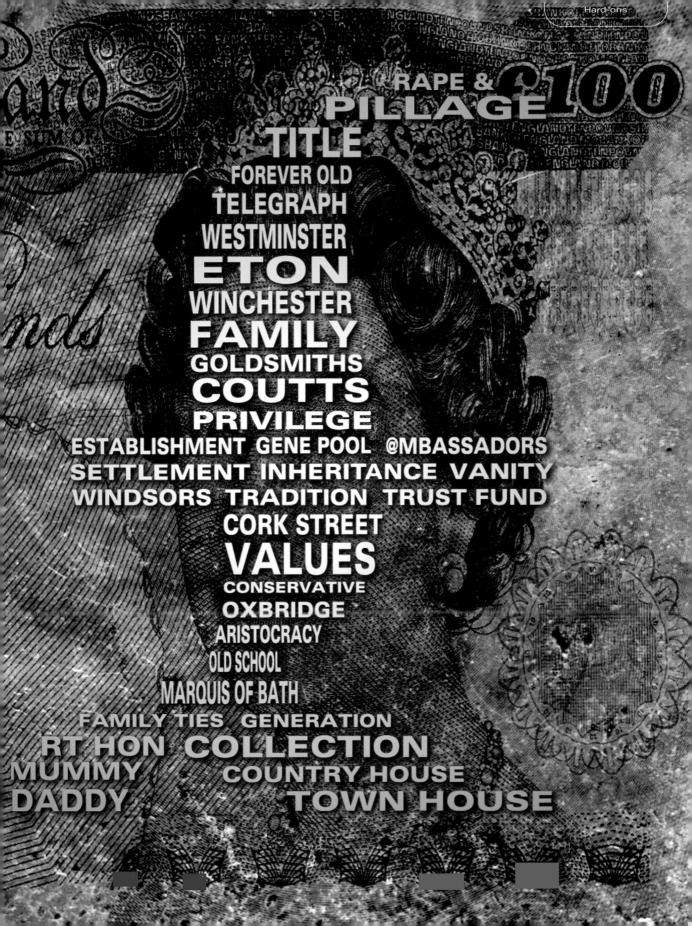

Definition: originated in Hollywood, created by
Don Simpson; the art of the 'one-line pitch', the
ability to encapsulate a total creative concept in
2 5 w o r d s o r l e s s

HIGH
HIGH
Concept CONCEPT

High Concept

8 • Macrohard - *"I Want To Be Erected"*
Music by Erb, Hughes, Sexton
(Copyright Control)
Produced by Macrohard
Vocals: Eugenie Arrowsmith
Engineer: Mark Rutherford
Architects Erected: Claudio Silverstin, Jonathan Ellis Miller, Mark Prizeman,
Hester Gray, Tim Boyd & Alex Michaelis, Carlos Villancuva Brandt

9 • Marc Quinn & Brian Eno - *"Sensual Zero Gravity"*
Written by Brian Eno & Marc Quinn
Published by Opal Music / Copyright Control

12 • Rufus Knightwebb & Derrick May - *'Silent Revolution'*
Written and produced in Detroit by Derrick May
Remixed in London by Rufus Knightwebb

We have *NO* oblig

We have *NO* obligation to make art

'The pursuit of making money is the only reason to
m a k e m o v i e s .
We have NO obligation to make history.
We have NO obligation to make art.
We have NO obligation to make a statement.
Our obligation is to make money and, to make money, it may be
n e c e s s a r y t o m a k e h i s t o r y .
To make money, it may be important to make art, or some such
s i g n i f i c a n t s t a t e m e n t .
To make money, it may be important to win the Academy Award,
for it might mean another ten million dollars at the box office.
O u r o n l y o b j e c t i v e i s t o m a k e m o n e y . '

Paramount Corporate Philosophy • Don Simpson, President of Paramount
Mr. High Concept Donald Clarence Simpson 29 Oct 1943 - 19 Jan 1996 - R.I.P.

We have *NO* obligati

to make history

Our *ONLY* objective is to make money

The spectacle is ideology par excellence, because it exposes and manifests in its fullness the essence of all ideological systems: the impoverishment, servitude and negation of real life. The spectacle is materially 'the expression of the separation and estrangement between man and man'. Through the 'new power of fraud,' concentrated at the base of the spectacle in this production, the new domain of alien beings to whom man is subservient... grows coextensively with the mass of objects. It is the highest stage of expansion which has turned need against life. 'The need for money is thus real need produced by political economy, and the only need it produces.' *(Economic and Philisophical Manuscripts).* The spectacle extends to all social life the principle which Hegel (in the *Realphilosophie of Jena*) conceives as the principle of money: It is 'the life of what is dead, moving within itself.'
'Society of the Spectacle' • Guy Debord *1967*

make a statement

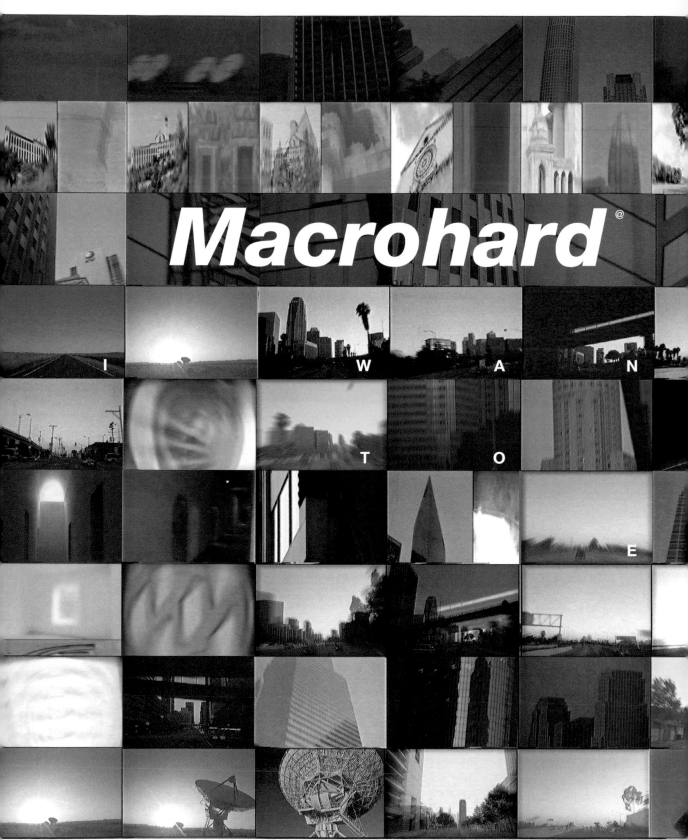

are

Macrohard®

'I Want to be Erected' • *Architectural stills taken from* Macrohard's *short film directed by* Duncan Ward

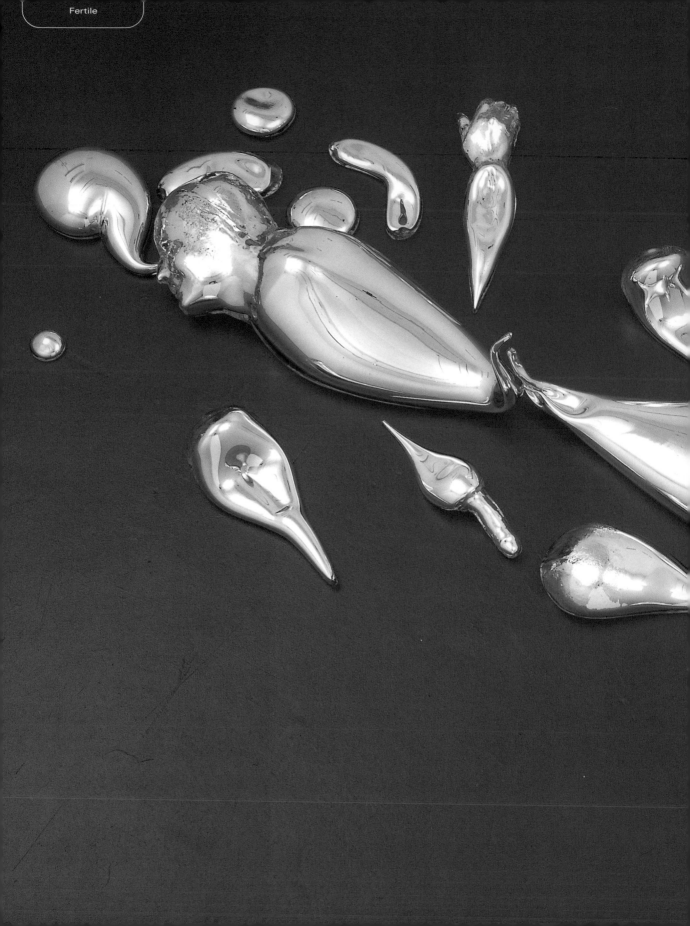

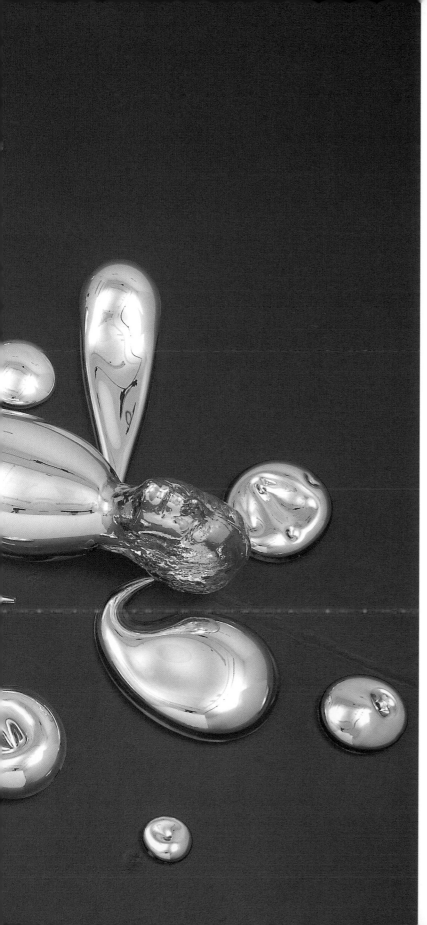

'♂ ♀ (xxy)' • Marc Quinn *1997. Glass and Silver*
Photo by Stephen White

but

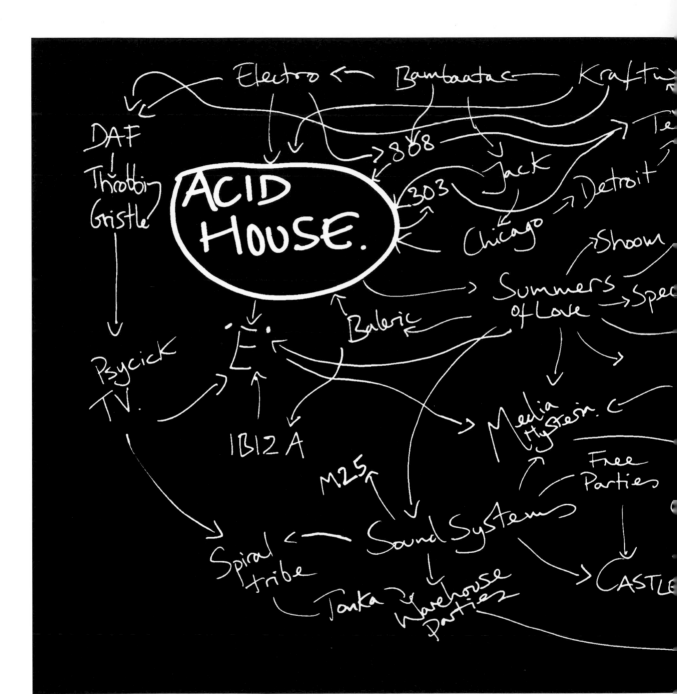

'The History of the World' • Jeremy Deller *1997*

Hardcore → Break-beat — Drum N' Bass

A8

808 State

RAVE

The North

KLF

Gerald

Melancholy

Clapham Common

Parks

BRASS BANDS.

Civic Pride.

ivil

nest

Orgreave

Return to Work

Bandstands

3.

The Miners Strike

Pit Bands

ON

Deindustrialization.

Festivals ← — Open Air.

Artist's Studio, London • Rufus Knightwebb *1998*

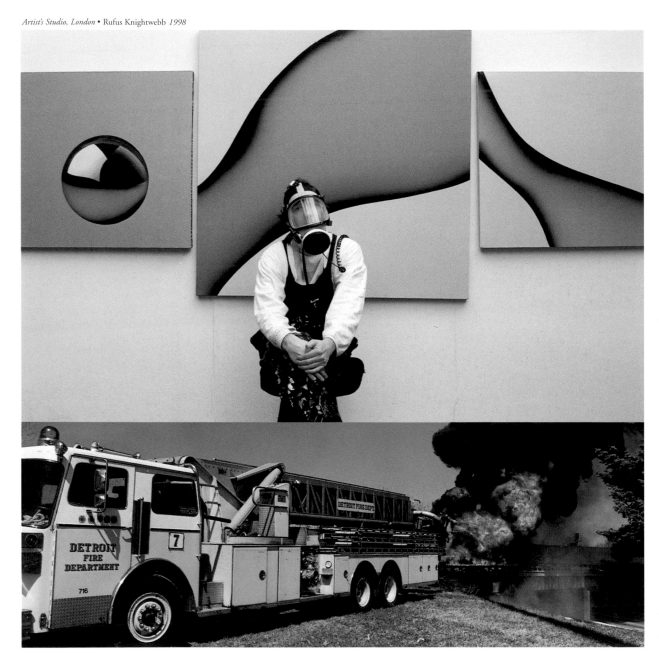

Detroit 1997 • Witnesses Rufus Knightwebb & Derrick May

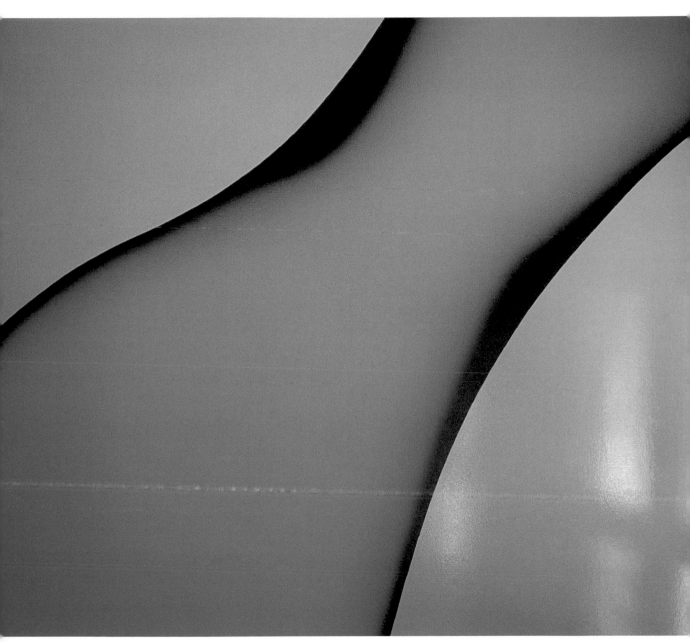

'*Summer Zephyr*' • Rufus Knightwebb *1998, 6ft x 6ft*

THUNDERSTICK:
THE SECRET
NAME OF GOD.
DETAIL FROM A
CHRISTIAN
FRESCO
SHOWING THE
AMANITA
MUSCARIA
AS THE TREE OF
GOOD AND EVIL
IN THE GARDEN
OF EDEN. "U"

SECRET *Histories*

SECRET HISTORIES

SECRET HISTORIES

Secret Histories

4 • Ashley Bickerton & Gray - *"Gray Presents, The Mysterious Mister Bickerton!"*
Written and Produced by Nicholas Taylor and Michael Holman
(Copyright Control)
Conversation written and performed by Ashley Bickerton and Helene Guetary
Vocals, Keyboard, and Synthesizer: Michael Holman
Vocals and Guitar: Nicholas Taylor
Percussion: Prairie Prince
Bass and Flute: Ethan Smith
Strings: Susan Mitchell
Recorded at: WK Studios *(New York)*, Studio de la Lune *(Paris)*
and down the telephone line to the Indian Ocean (Bali)

6 • Towering Inferno - *"Crash"*
Written by Wolfson, Saunders and Pouncey
(Copyright Control)
Performed by Towering Inferno
Programming by Richard Wolfson and Andy Saunders
with special guest: Sav X - *words and voice*
Crash is a sketch towards Towering Inferno's new show and album 'Physical Cinema'. The first performances of Physical Cinema have been commissioned by the Greenwich and Docklands International Festival of Summer 1999

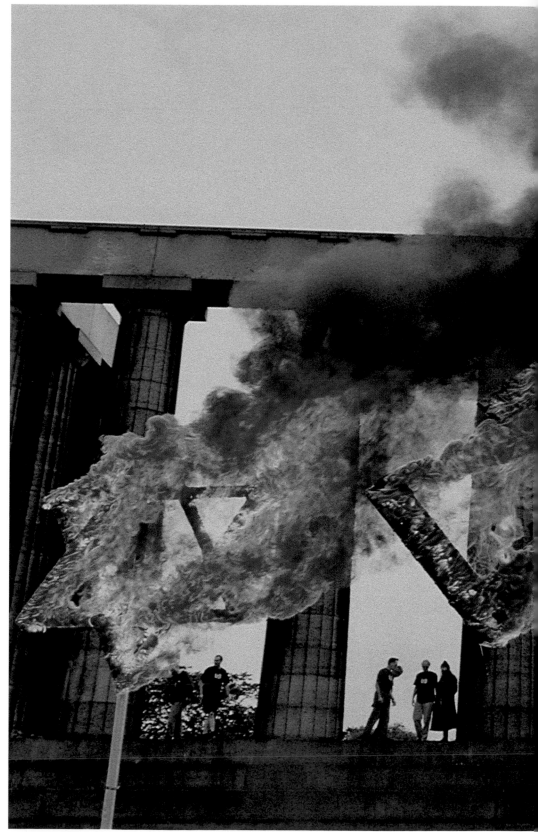

And

Performance, Edinburgh Scotland • Towering Inferno *August 1996. Witness* Murdo MacLeod

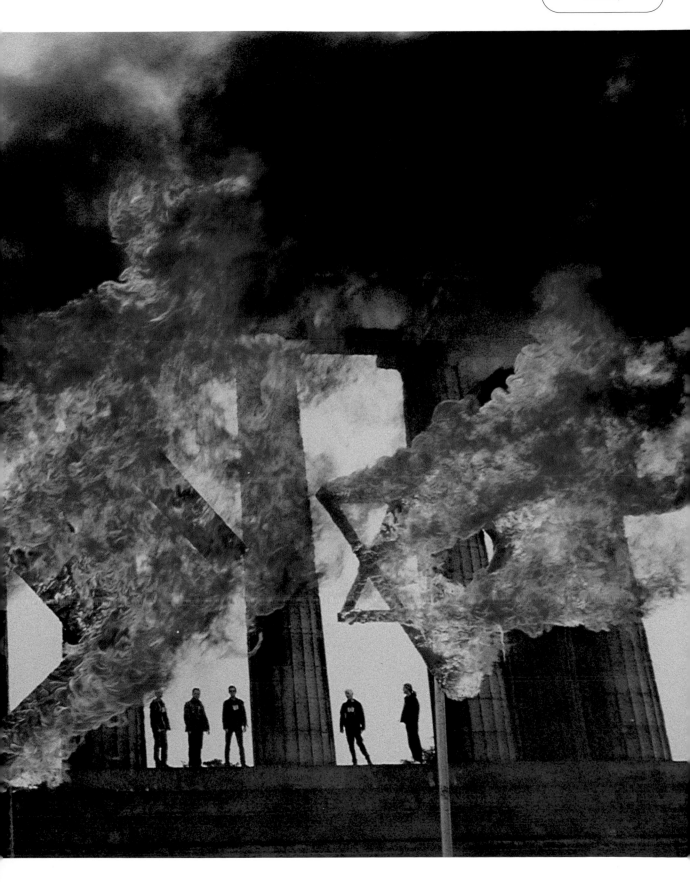

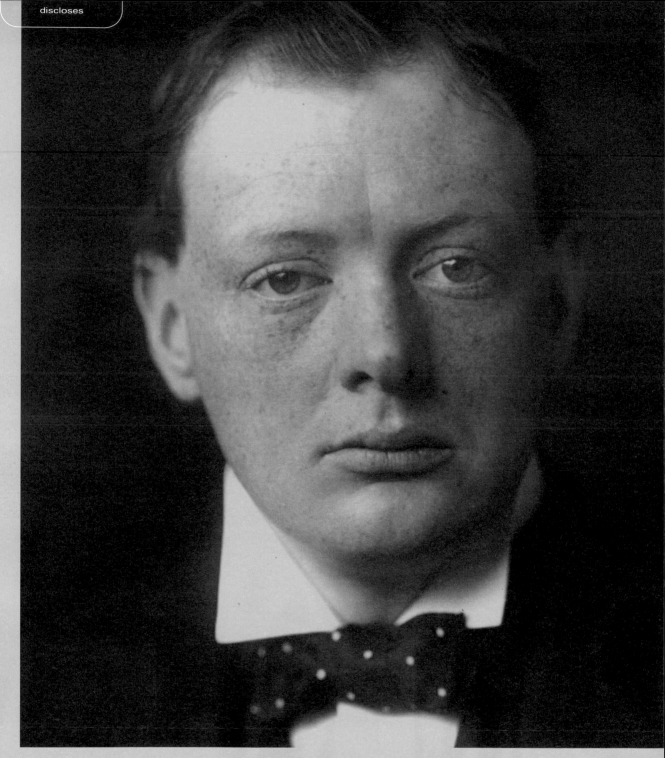

The @mbassadors warn
Sir Winston Churchill of the
B l a c k D o g

Britons always loyally declaim
About the way we rule the waves
Every Briton's song is the same
When singing of her soldiers brave...
We're not forgetting it, we're not letting it
Fade away or gradually die!
So when we say that England's master
Remember who made her so!

It's the soldiers of the Queen, my lads,
Who've been the lads, who've seen the lads
In the fight for England's glory, lads -
Of her world-wide glory let us sing!
And when we say we've always won
And when they ask us how it's done
We'll proudly point to every one
Of England's soldiers of the Queen!

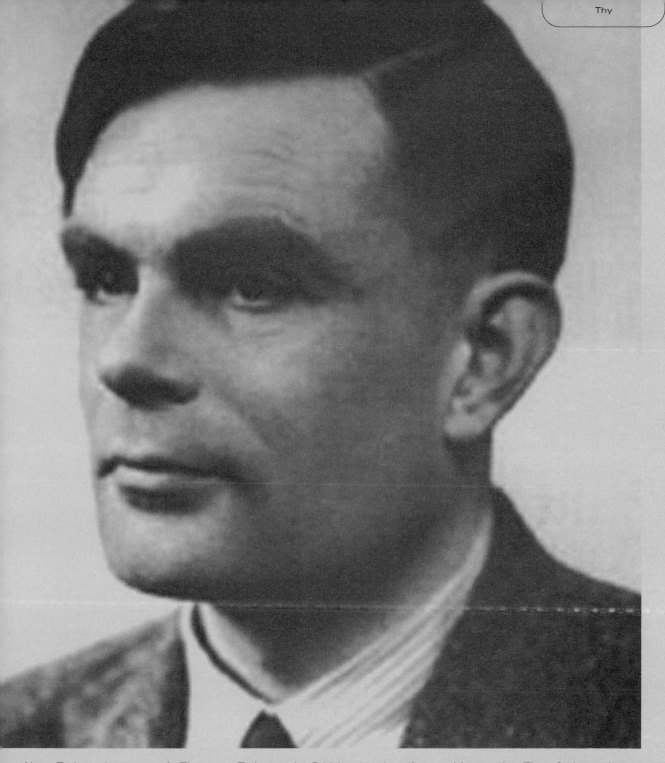

Alan Turing, inventor of The Enigma Machine, precursor to the computer, and the concept of artificial memory. The @mbassadors invite Alan Turing to the British screening of W a l t D i s n e y ' s S N O W W H I T E and warn him of the b a d a p p l e. Afterwards The @mbassadors drive to Cambridge to host a d i n n e r p a r t y. Present are Wittgenstein, Blunt, Burgess, Philby and MacLean.

THE HYPOCRITE I
THE LOOSE WICKED M
THE SECURE, BOLD AND PROUD T
HE WHO WILL NOT BE TAUGHT O

'From the standpoint of the infinite, blessed be He, all the worlds are as if literally nothing and nihility' • Rabbi Shnew Zalman, from The Habad

AN AMBASSADOR
N IS AN AMBASSADOR
NSGRESSOR IS AN AMBASSADOR
REFORMED IS AN AMBASSADOR

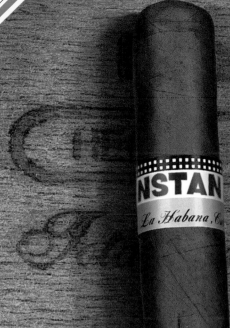

Roses

INSTANT *Gratification*

INSTANT

Gratification

La Habana, Cuba

CUBATABACO

'Instant Gratification' • Milo Hennessy 1998, cebachrome on multi dimensional perspex

(1) "I command the absence of light," said the box

In 840 A.D. the Frankish king, Charles the Bald, commissioned the eminent philosopher John Scotus Erigena to define the existence of God. Having absolutely no idea of how to tackle the question, he consulted the @mbassadors. The answer they gave him he quoted verbatim to the king, pretending however that the answer was his own. "We do not know what God is. God himself does not know what He is because He is not anything. Literally God is not, because He transcends being."

When asked their opinion of the renowned philosopher the @mbassadors replied: "Essentially he was a gullible idiot who would believe anything you told him."

(2) "I discovered space between earth and stone," said the shining beetle

While working on his General Theory Of Relativity in 1915 Albert Einstein consulted the @mbassadors on the behaviour of gravitational masses, relativistic time dilation, the geometry of space and geodesic pathways through gravity. Apparently the great physicist was not too impressed with their initial answers. "Do you fuckers know anything?" demanded Einstein, to which they replied "Hey, does God play dice?"

(3) "I fed my young with your decaying flesh," said the fly

Being disturbed after a bad trip in the garden of Gesthemene, Jesus consulted with the @mbassadors at the crucifixion, one at each side. However they were too late to save him.

(4) "I kissed your mouth, and then I left"

They tried to persuade Judas to keep the money, but he just wouldn't listen.

(5) "I threaded my thoughts through her dreams," said the lover

Mata Hari consulted with the @mbassadors shortly before her arrest. They told her everything they knew about sex. In return she told them everything else.

(6) "I severed the butterfly's silken dress," said the blackbird

The @mbassadors have been witness to every major assassination this century, including that of themselves, of which they disapproved. Illusion is sacred, truth profane.

Sex W. Johnston

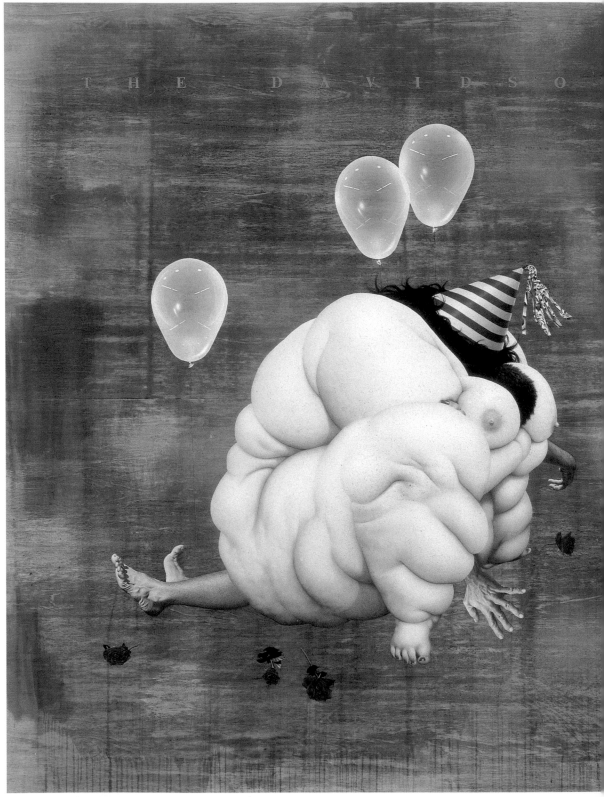

'The Davidsons' • Ashley Bickerton *1997. Oil, acrylic and aniline dye on wood. 94" x 126"*

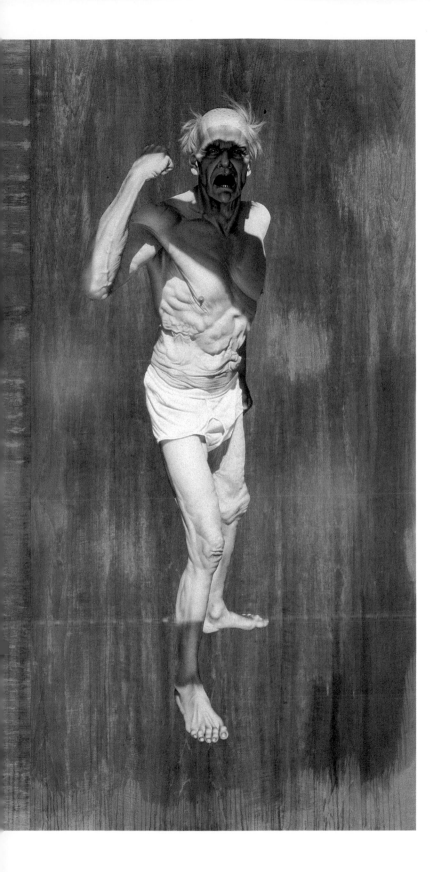

LONDON • NEW YORK *14TH MAY 1998*

@mbassadors: Who is the enemy?

Gray: It's too obvious - mediocrity and lack of inspiration - forces that would keep us from being creative, inspired and evolve. I see a great demon in the sky full of negativity pulling at the earth making us go in certain directions.

@: Who is Mr. Bickerton?

G: He is a romantic figure who cuts a rakish debonair profile in a very cosmic and electrophysical way. He is also in exile because he is so ultra romantic that you can't stop Bickerton from eternally escaping being defined. A romantic visionary on the run.

@: What is your secret?

G: Faith that we're the coolest muthafuckers on Earth. We are totally inspired almost 100% of the time, looking at the world, like what the hell's going on out there. Our inspiration is our secret.

@: What are you hiding?

G: Fear of discovery that it's all just what it is and nothing more. That there's nothing magical or exciting behind it all that justifies our artistic exploration and suffering and attempts at breaking through to the other side.

@: Do you ever hear voices?

G: In moments of meditation I hear all kinds of voices. I believe that they are some sort of neurological residue that collects on the nerve ends. I'll hear a word or sound or voice for a split second that really exists but it exists as a purely electric synapse that jumps around in your nerve ends and brain. During moments of contemplation I'll be reaching out for the universe and asking questions and the voices that I hear sometimes are very direct answers, voices that are peeking through and reaching into my mind somehow.

@: Who is the Master of the Universe?

G: The Power Clown.

@: Who are the ambassadors?

G: The overlords. Here's how the ambassadors work - you're lying in bed smoking a little pot nothing bad and you look up at the corner of the ceiling of your bedroom as you're watching the Knicks game and you notice there's a shiny little glass thing in the corner of your room and you go up and you look at it and you realise that it's a micro lens and you pick at it and you peel this thing out of the old moulding of your tenament flat in the East Village and you dig this lens out and you realise that someone's been fucking watching you.

@: Is there a conspiracy?

G: Definitely. A subconscious underlying conspiracy in people's minds driving the World on and on. The conspiracy, the one and ultimate conspiracy is the UFO thing hiding the overlords. When I went to get my friend to show him the micro lens, when we got back to the room the wall was completely patched up like nothing had happened.

Una Serata con l'Abasciatori di Musica

D. Mi spiega la teoria di "We Love You" (Ti Vogliamo Bene)
R. Estato creato come arte sonica, una collaborazione tra
 originatore, produttore DJ's insieme con Artisti di belle arti
 conteporania Britanica. Il disco e d'avanguardia equivalante al
 sentimentalismo uditivo. Il progetto e impressionare,
 controversia "la scossa del nuovo"
D. Ma siete dei sciavi al servizio dei dittatori
R. Va fanculo. Noi siamo la mucca che mungia il Toro
D. Chi e il nemico
R. Il nemico si trova dentro di te - fuori di te
D. Dove abita Dio
R. Spazio e troppo complicato per un Dio
D. Ma ce una conspirazione
R. Si ce un gioco degli scachi e tutti i pezzi sulla scacchiera
 sono grigi
D. Vai a casa da solo
R. Non andiamo mai a casa
D. Ci credi nel sesso
R. Siamo gia troppo provocante per i nostro sonetti
D. Ma ci credi nel'amore
R. We love you
D. Ma siete capace
R. Ma si
D. Mangia carne
R. Carne umana? Sene fa una buona carne di maiale
D. Ma sei un cane che ha la peggio
R. Siamo dei cani ala grande
D. Who fucks the fucker
R. Nessuno

La sua arte non ha alcun rapporto con la musica tradizionale e
invece lo sviluppo del principio come Malevic, che voleva
L'artista liberato dalla servitu del piano.
Se l'arte deve continuare a vivere dovra assere l'asciata libera
nuovo, porta paura e offende il establishment Inglese.
Viva la liberta del pensiero.

Umberto Primo, *21st May 1998*

TROPHY ART

Trophy Art

3 • Jessica Voorsanger • Dumb Angel - *"You're My Favourite Popstar"*
Performed by Dumb Angel with Jessica Voorsanger
Published by Chrysalis Music (Copyright Control)
Music & Production by Dumb Angel (Dominic Dyson & Darren Pearson)
Vocals: Jessica Voorsanger
Lyrics: Jessica Voorsanger & Bob Smith

thine

Trophy Art

The must haves of Institutions • Multi National Corporations
Private Collectors • The Dealers • The Sponsors • The Players
The Dead • The Artist Come Player/Dealer...

This is the principle of commodity fetishism, the domination of society by "intangible as well as tangible things" which reaches its absolute fulfillment in the spectacle, where the tangible world is replaced by a selection of images which exist above it, and which simultaneously impose themselves as the tangible par excellence.

The world at once present and absent which the spectacle makes visible is the world of commodity dominating all that is lived. The world of commodity is thus shown for what it is, because its movement is identical to the estrangement of men among themselves and in relation to their global product.

Guy Debord, *Society of the Spectacle, 1967 Paris*

A lively, new polemic about the concepts "one divides into two" and "two fuse into one" is unfolding on the philosophical front in the country. This debate is a struggle between those who are for and those who are against the materialistic dialectic, a struggle between two conceptions of the world: the proletarian and the bourgeois conception. Those who maintain that "one divides into two" is the fundamental law of things are on the side of the materialistic dialectic; those who maintain that the fundamental law of things is that "two fuse into one" are against the materialistic dialectic. The two sides have drawn a clear line of demarcation between them, and their arguments are diametrically opposed. This polemic reflects, on the ideological level, the acute and complex class struggle taking place in China and in the world.

The Red Flag of Peking, *September 21, 1964.*

"Two Fuse Into One" • "Class War" • "Return Of The Radical Chic"

@mbassadors - *1st May 1998 London*

WE

LIVE TO

TREAD ON KINGS

groovy groovy you're sublime
YOU'RE MY
FAVOURITE POPSTAR
without you, i'd drink turpentine
I'VE GOT
THE KEYS
TO YOUR FLAT

dumb

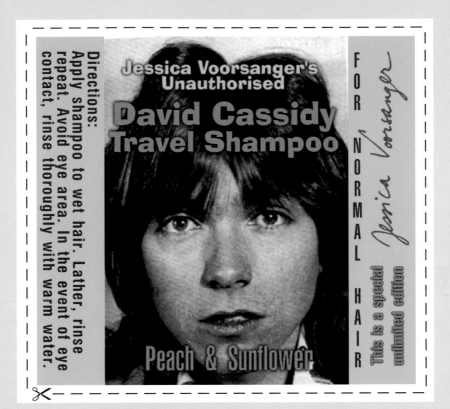

Jessica Voorsanger's Unauthorised
David Cassidy Travel Shampoo

Peach & Sunflower

FOR NORMAL HAIR

Jessica Voorsanger

This is a special unlimited edition

Directions:
Apply shampoo to wet hair. Lather, rinse repeat. Avoid eye area. In the event of eye contact, rinse thoroughly with warm water.

"O gentlemen, the time of life is short!...
And if we live, we live to tread on kings..."

William Shakespeare, *Henry IV*

Trouble from the Grave

18 • Gavin Turk - *"My Way"*
Written by P. Anka, C. Francois, J. Revaux, G. Thibault
Vocals by Gavin Turk
Vocals recorded by Tom Rixton at Eastcote Studios
Produced & mixed by Dub Pistols

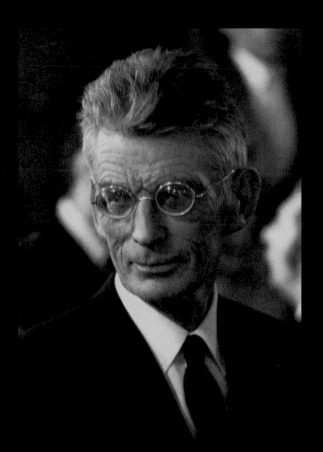

Joyce smoyce your poems

Beckett Feck It C R I M E

"Unpredictability and transmutability are the essence of nature...."

"Awe is taboo to start with, since it has to do with very deep levels of emotions.

And it is the disarousal of emotions that is at the centre of all this.

Deep levels of emotion tend to cripple action, will inhibit 'das Einschreiten' that is the key operation.

You have a rebellion of the 'Fallen Angels'. Certain basic human reactions are OUT.

Around nature, there are a multitude of layers going back very far. Assertions of meaning and significance, layers of emotions, historical associations.

The entire development of art is indivisibly fused with nature and with concepts of nature: poetry is shuddered with Nature".

Gustav Metzger - 'Damaged Nature, auto-destructive art' (V2 s'Hertogenbosch, Netherlands 1992)

" Nature makes us nervous "

@mbassadors (Peter Gabriel's pilo, Box, Bath 1998)

In 1981 the year after Metzger had finished his 'three years without art' he challenged Beuys on the workability of one of his more popular statements, that "Every human being is an artist". In front of more than 500 people, at a discussion coinciding with the Westkunst exhibition curated by Kasper Konig and Laslo Glozer in Cologne, Metzger stood up and asked Beuys:

"Joseph Beuys: Jeder Mensch ein Kunstler! Himmler auch?"

To this question, trapped by his own formulation, Beuys replied in the affirmative.

The @mbassadors would like to ask Mr. Metzger:

"Gustav Metzger: You are a Vegetarian! Hitler too?"

Piero di Cosimo was particularly enthralled by the freaks or accidents of nature, and often sought out strange plants or other objects that nature had produced by chance or from some unfathomable whim. Transported by his enthusiasim for these objects he would describe them at such length that it became tedious even to those interested in such things. Piero di Cosimo also possessed a fascination with the shapes that appeared on walls against which sick people had spat, or those in clouds, which he would stop to contemplate, and from which he would extract the forms of battles, fantastic cities or vast landscapes. As he travelled along his eccentricities increased, he became prey to strange fears and fancies, and so strange and eccentric (fantastico) in his manner that no-one could endure him. He ate only hard-boiled eggs, which he cooked fifty at a time. He would not allow his rooms to be cleaned or his garden hoed. He refused to prune his plants or fruit trees, and let the vines run wild and shoots spread over the ground, for he loved to see everything grow wild and uncultivated (selvatico) around him. His life was more animal (bestiale) than human, he took such pleasure in it that anything else struck him as a form of slavery.

Piero di Cosimo (1461-1521)

Vasari's Life of Piero di Cosimo
from the 'Lives of the Artists'
(1550 featuring Michelangelo, Leonardo da Vinci & Piero di Cosimo)

Under the shimmering diversions of t h e spectacle, *banalization* dominates m o d e r n society the world over... the celebrity, t h e s p e c t a c l e representati on of a living h u m a n b e i n g , embodies this banality b y embodying the image of a possible role. Being a star means specializing i n t h e seemingly l i v e d . . . celebrities existed to a c t o u t v a r i o u s styles of living and v i e w i n g society- unfettered, f r e e t o e x p r e s s themselves *g l o b a l l y*

'Bum Negative' • Gavin Turk *1998*

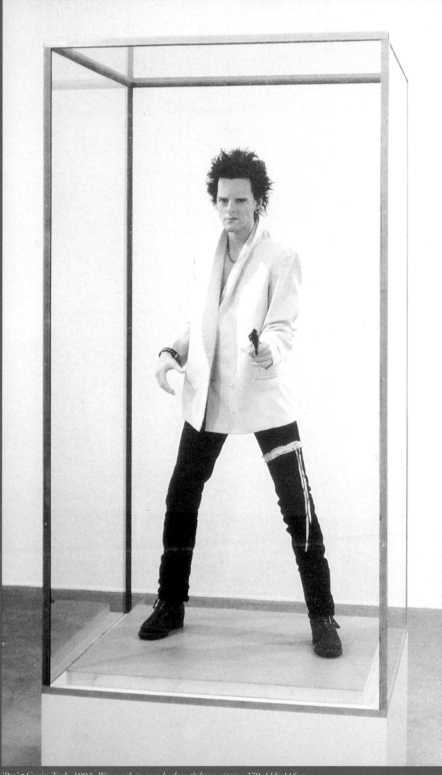

'Pop' • Gavin Turk *1993. Waxwork in wood, glass & brass vitrine 279x115x115cm.*

'rock 'n' roll people love F r a n k S i n a t r a because F r a n k Sinatra has got what we w a n t swagger a n d ATTITUDE HE'S BIG ON ATTITUDE B A D ATTITUDE Frank's THE CHAIRMAN OF THE BAD

rock 'n' roll p l a y s at being tough, b u t t h i s guy's...well, h e ' s t h e b o s s o f bosses. The Man. The Big Bang of P O P .

I'M NOT GOING TO MESS WITH HIM ; ARE Y O U ? '

Bono

The
sarcophagus
was found deep
under the Temple of
Traitors. According to the
inscription displayed in legend
at the bottom of the lid it is the
mantra of the @mbassadors - 'you lied,
you cheated, we love you'. In the middle of
the sarcophagus five ancestral portraits depict
each deity emerging along with a logo now attributed
to the late 20th century political cult of Eastern Europe. The
sarcophagus was carved from a soild white marble cube with
silver inscription. Since the enormous base is larger than the
entrance to the chamber, it must have been in place before the
p y r a m i d a b o v e i t w a s c o n s t r u c t e d .

After the burial rites were completed and the chamber sealed five concentrated
tobacco leaves (Cuban) were laid in a small chamber in front of the white marble cube. The
entire image is enclosed in a gold frame reminiscent of the Baroque period.

Traitors Gallery

but

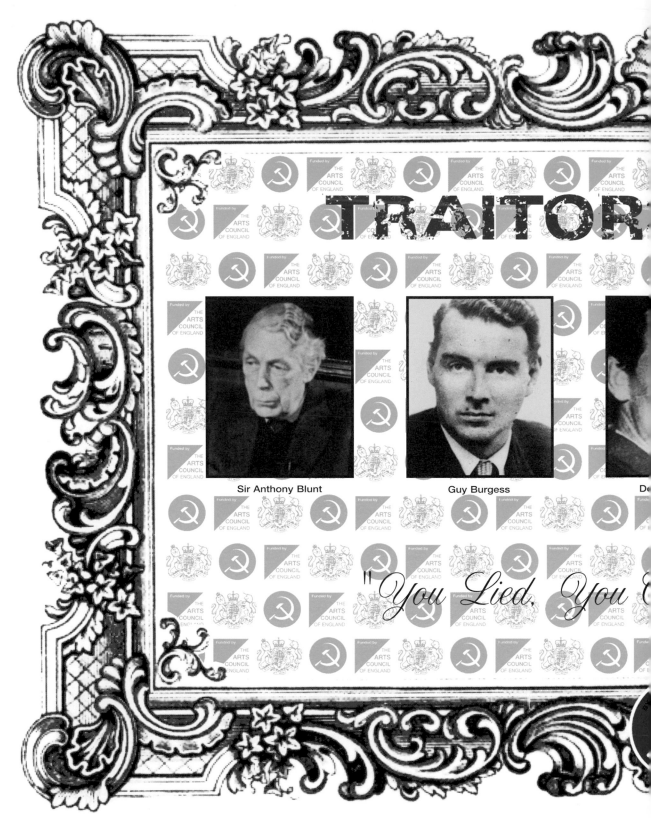

Sir Anthony Blunt **Guy Burgess**

TRAITOR

"You Lied, You

'Who amongst us has not committed treason to something or someone more important than a country?...'
Extract from: foreword to 'My Silent War' • Graham Greene *(autobiography of Kim Philby).*

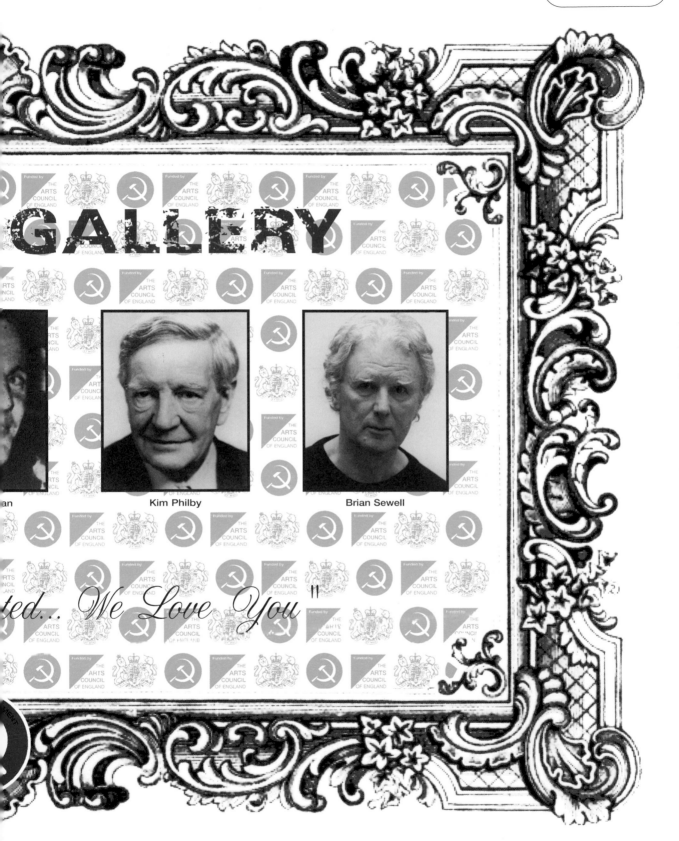

GALLERY

Kim Philby

Brian Sewell

...ted... We Love You "

'Traitors' Gallery'

"As autopsy reports and pharmaceutical records would later reveal, Simpson through the summer of 1995 was on a regimen that included multiple daily injections of TORADOL, for pain; LIBRIUM, to control his mood swings; ATIVAN, every six hours, for agitation; VALIUM, every six hours, for anxiety; DEPAKOTE, every six hours to counter 'acute mania'; THORAZINE, every four hours for anxiety; COGENTIN, for agitation; VISARIL, every six hours, for anxiety; and LORAZEPAM, every six hours, also for anxiety. He was also taking, in other forms, 19 other drugs, including morphine. A law-enforcement source estimated his monthly prescription expenses at more than $60,000. These medications were being ingested, autopsy reports would show, in addition to large quantities of alcohol and cocaine".

High Concept: Don Simpson And The Hollywood Culture Of Excess, C h a r l e s F l e m i n g

Love, Intoxication

17 • Georgina Starr - *"All About Love"*(from *"Tuberama" the Musical*)
Music composed by Jobe Talbot
Lyrics and vocals by Georgina Starr
(Copyright Control)
Engineered by Jon Jacobs
Mixed by Dave Tyler
Recorded at Westpoint Studios, London

5 • Tracey Emin / Boy George - *"Burning Up"*
Words by Tracey Emin
Music by Boy George
(Copyright Control)
Produced by Boy George
Engineerd by Ritchie
Recorded at More Protein Studios, London

13 • Sam Taylor-Wood - *"Je t'aime ... moi non plus"*
Written by Serge Gainsbourg
Published by Editions Melody Nelson
Produced by Pet Shop Boys
Engineered and programmed by James Sanger

INTOXICATION LOVE

Syd Barrett once took a monumental acid trip, decided to lock his girlfriend in the bathroom for five days. He fed her cheese biscuits under the door and told her she could drink from the toilet bowl if she liked. Soon after being let out, (not by Syd) she left him

When a person is entering deep sleep, then all the consciousness goes through the seventy-two thousand subtle channels that lead to the heart's centre from its circumference. At that time the soul rests in the covering around the heart zzzzzzzzzz

TRACEY EMIN

FANTASY

NEW YORK

ISLAND

MAY 2nd 1998

You know that girl you fancy. The one with dark brown eyes and fucked up smile -

Well, I was sitting on her face the other day -
My arse pressed right up close against her nose - I was really drunk, wearing high shoes staring into the mirror -
Her legs were wide open - And I was rubbing her

mean no one makes a pass at me.

But he just stood there - all muscle wagging his tail - And a real sexy voice - Slow and somehow penetrating. He just came right out with it. Hi Trace - do you fancy a fuck.

I mean I was surprised first he knew my name

with emotion -

Yea - I said you're good looking - but you're a dog -

Cocking his head to one side - he looked at me - looked at me like I was shit.

Tracey you surprise me he said you - you of

back. The other hand on my hip.

He slowly pulled me over to the stairs. His hand thrust right up my cunt - A whole fist - like a cork - And behind the fist - enough of my cum to fill a fucking saucepan -

A hood was put over my head - my legs and arms were tied behind my back - I was thrown into the boot of a car.

I woke up to the smell of jasmine and the sound of beautiful birds - I was laying on a wooden floor. The phone was ringing. I crawled towards the phone and knocked the receiver off with my chin -

It was your voice - you said you were coming to save me

A door opened - you picked me up - threw me onto the bed - and started to fuck me like crazy - like you'd been in prison for 7 years - wanking day in day out - over panty lines and support stockings -

Your cock was so hard - moving like crazy - up my arse - my cunt my arse -

My head sank deep into the pillow I was losing consciousness - like I didn't exist anymore.

Like my soul was in Heaven - like I was loving you forever and ever and ever - like I'd met you in eternity

And then I felt it -

first my head - the barrel of a shot gun - cold - aiming deep into the back of my mind - then fuck - right up deep inside of me - straight to the neck of my womb -

I was screaming - get it out of me - in the name of God it hurts for fuck's sake save me - get it out of me -

There was blood - blood - deep red blood everywhere -

I was on my back - going somehow crazy - my cunt ripped into two - the cord was cut - I was crying - c r y i n g uncontrollable tears - my baby was lifted into my arms - you kissed me - and I felt beautiful.

clit - really fast. I mean fast - like I was playing air guitar.

She was moaning and whimpering. But me - me I kept really quiet. I was thinking about that dog - the one that tried to chat me up - on the bridge - that small japanese wooden bridge. It was strange - I

and 2nd dogs don't talk. He kind of then smiled in a doggy way - well what about it?

No, I told him - I couldn't believe I was talking to a dog -

What's wrong he said don't you find me attractive - His face looked kind of hurt - And his big eyes seemed to fill

all people - I never put you down as being prejudiced -

By now her black lace nickers were torn to shreds - she was still moaning and groaning.

The cameras were doing a 360 spin - and the lights were blinding me - His hand was gently rubbing my

TRACEY

ALL ABOUT LOVE

MUSIC COMPOSED BY
JOBY TALBOT

LYRICS & VOCALS
GEORGINA STARR

I DID MY RESEARCH & READ UP ON HOW
TO FALL IN LOVE & WHERE TO GO TO FIND
THE PERFECT LOVING SURROUNDINGS.....

SO I STARTED GOING OUT EVERY
NIGHT TO FALL HEAD OVER HEALS — PARTIES,
CINEMA DATES, BARS, NIGHT CLUBS

WHEN SHE WAS FULLY
GROWN WE WENT OUT TO
CELEBRATE.....

SO NOW, THE REAL ME IS AT
HOME, ENJOYING SOLITUDE IN
A THOUGHTFUL MELANCHOLIC
HAZE.....

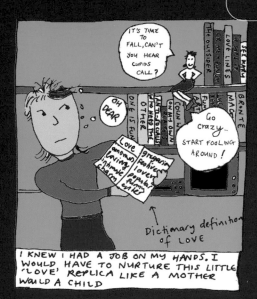

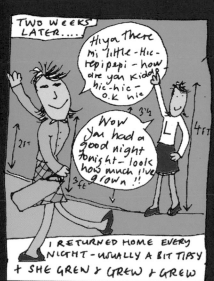

Take the teeth
Take the dung
Take Add N To X
and put that all together in one
Treat with O & F & I & L & I

Take the teeth
Bite the face
I love it
Take away the teeth and give me the dung
Give me Add N To X

Add N & X multiply by O F I L I
Equals adding elephant dung
To a synthesized musical system

Elephant dung smells
Steve smells
Ann Smells
Barry smells
Ofili smells

Take the teeth
Take the face
The teeth, the bite, the face
I love it
Take away the velocity of air
Take away 332 metres per second
And add that to N and X

Take O from F from I from L from I from
And sell elephant dung

I shat them out
I Ofili have shat them out
Get out of my body
And add N to X
Shit them out
Shit the electro sound from my mouth

Add N to X
Remove that from the elephant's arse
Add that to O
Subtract N and X
And you have electronic shit

I shall put an N and an X
Into my dung and sell it

Add N to X
Add O to F minus I divided by L plus I
Equals electronic shit

Casino Economics, Mesmerisation and the Harmony of Numbers

16 • Jane & Louise Wilson / M I 7 - *"Hypnotic Suggestion"*
Written by Dave Ball, Ingo Vauk, Jane & Louise Wilson
Published by Deconstruction Songs / 19 Music /(Copyright Control)
Produced by M I 7

11 • Chris Ofili / Add N To X - *"The Fullness that Fills up the Pulse of Durations is Full"*
Written by Barry Smith, Ann Shenton, Steven Claydon, Chris Ofili
(Copyright Control)
Produced by Add N To X and Yossarian

10 • Big Bottom - *"No. 2"*
Written by Susan Stenger
(Copyright Control)
Performed by Susan Stenger, Angela Bulloch, Cerith Wyn Evans, J. Mitch Flacko and Tom Gidley
Recorded at Greatorex Street Synagogue/Commercial Too, London, September 1997
Engineering and post-production by Paul Kendall
Pre-mastering EQ by Robert Poss

'Do you become disillusioned with the hype and hypocrisy?' (*No more beauty execpt in strife*)

The entire life of societies in which modern conditions of production prevail displays itself as an *immense accumulation* of love. Can everything be directly lived or has it now all moved away into representation?

Two pieces of pinkish cloth, back to back, sewn together to form a T-shirt, zips (nipple zips) – and then the words silkscreened over the front: 'I groaned with pain as he eased the *pressure* in removing the thing which had split me and then, his huge hands grasping me at the hips my *blonde hair* forming a pool on the dark wood between his feet, he raised me to doting love soothing the bleeding lips and causing the tearing commotion at my loins to subside in a *soft corrosion*'. These words were taken from Alex Trocchi's pornographic book *The School for Sin* by Malcolm McLaren and used for one of his earliest T-shirts produced at Sex. This was pornography that, written for straight *money* and published by Maurice Girodias's Olympia Press in Paris in 1955, laid the foundations for Trocchi's Situationist-inspired vision of what he called, variously, a 'metacategorical revolution', the 'Invisible Insurrection of a Million Minds' and, more directly, a 'coup de monde'. Trocchi's *revolution* was to be found within his formation of Project Sigma and International Cultural Enterprises – a sort of junk-fuelled UNESCO that might herald the dawn of a new age as much as it was to become a formative icon for McLaren's coming revolution of media-manipulation. Here, in this artefact, can be found not only traces of an *extreme experience* of life but also signs of its mediatisation, representation, mediation and commodification.

For Trocchi the acid bath of pornography, provided an example of an excess of experience (one model for his writing were the *libertine* narratives of the Marquis de Sade) that might attack and demolish the established culture of the day; where sex, like drugs, acts as the 'invisible catalyst of a complex process of experience' and where visions of new worlds can be erected. Worlds constructed from such *uncontrollable pleasure* so that, in this extreme exhilaration, we are left wet with fear at the distance we have gone. Yet pornography – arse-licking, shit-stabbing, mother-fucking, spunk-loving, ball-busting, cock-sucking, fist-fucking, lip-smacking, thirst-quenching, cool-living, ever-giving – as Trocchi was only too well aware, more usually takes its position within the structure of the spectacle as a contrived representation of those liberating forces and so exists as an agency that is also oppressive and controlling, that must be broken down and dismantled.

Sometimes I wonder what it's all about and think about the world's endless transformation as a *playground* into other ideas of other worlds where life becomes 'a game just for playing', and where the accepted means and order of classification are broken up and discarded so that we can face a new landscape. A sonic landscape and now a sonic artfutique – a collectible piece of the future. Collaborations between artists and musicians have been a constant throughout the history of 20th-century art; from Italian Futurism and the noise machines of Luigi Russolo to the mixture by Fluxus of *vaudeville*, childrens' games and John Cage in their events and on to Pop art and the Exploding Plastic Inevitable of Andy Warhol. For these artists music is just another medium. One explanation for this interplay between an avant-garde culture and a popular mass culture, beyond the search for new subject-matter, is to be found inscribed within the *utopian* desire for a revolution in everyday life in which social relations and the relations between things can be upset and *manipulated*. Everything that has always limited and restricted the free play of experience is rejected; categories are turned on their heads, language taken apart and reformulated as a 'politics and architecture of ecstasy'. Inside and outside – inner and outer space – merges to form buildings of *desire*. Function is replaced by the action of love where we become blind in a world of *sensation* – 'kick out the jams, motherfuckers/ sexual intercourse/ no known cure'.

The Living Sculptors Gilbert & George have always formulated their work as 'visual love letters to the viewer' created through the world of sensation and achieved by the search inside themselves for a new picture of the world; a picture that, as a '*frozen* example of thought and feeling', has the property to then change the world. They can only search for life, re-examine it and re-invent it through an art that is artificial – 'we don't know what life is all about, so you have to put up a new idea'. It is in this way that art has the capacity to change the way we view life; making a *reflection* would only show what is already known. Push at the boundaries and the boundaries move. They are similarly unforgiving in

what they present to us in their visual love letters – 'We cannot give to the people the pictures that they want, we have to do the pictures that we believe the world needs, otherwise we are just reassuring and restating what is already there. We believe that the artist has a responsibility. We believe that an artist should have a sense of duty... We believe that all culture creates the future and we want to be part of building the future. We want the world to be a little different because of our pictures.' Their world of love is also a world of *despair* and loss – a bloody world in which doors are locked and windows are jammed shut. It is a world that constantly cries out to be *reborn* and made anew. What we face is a world that is also splitting up and fragmenting; even art itself seems to have cut itself off from the general culture and art's direct attachment to and involvement with the structures of society today sometimes seems little more than a delusory *mirage*. As we move from one room to another, one flat to another, one house and one street to another, sounds carry and die, split off from their source and meaning. We are followed by sound – he's repositioned the speakers – our own and other peoples' that are constantly disappearing and coming round again in different guises; see the track listing, it is *inescapable*.

So what are we to do; I don't know which of your fingers will move first. How are we to make sense and select our material? One of the games I used to play at home was that there were snakes on the floor and so I would try and make sure that I didn't get bitten. Walk but not on the floor. I think looking back I would really

like to do that again. I love climbing. Or perhaps we could follow the example of 'Pataphysics: the science of the particular (despite the common opinion that the only science is that of the general) and, above all else, the science of imaginary solutions Rip it up, split it, build it up. Lost the self I lost that I never lost.

Sampling – liberating the groove – along with the use of the noise of everyday life in the place of more orthodox forms of instrumentation is no recent phenomenon. Russolo's 1913 manifesto, *The Art of Noises*, took its notation from the noise of the modern, industrial city. He ignored the traditional concert hall repertoire in favour of 'combining the noises of trams, backfiring motors, carriages and bawling crowds...We can enjoy orchestrating in our minds the crashing of metal shop blinds, the slamming of doors, the muttering and shuffling of crowds, the variety of din from railway stations, iron foundries, spinning mills, printing works, electric power stations and underground railways...One day the motors and machines of our industrial cities will be deliberately attuned, and every factory transformed into an intoxicating orchestra of noises.' Taking his cue from Filippo Marinetti's 1912 *Technical Manifesto of Futurist Literature* which called for the use of 'all brutal sounds, all expressive screams of the violent life which surrounds us ...[to produce] the "ugly" ... and to Kill solemnity everywhere', Russolo wholeheartedly embraced the violence of the new

industrial world with his noise machines each of which produced specific types of noise: gurglers, cracklers, howlers, thunderers, exploders, hissers, buzzers and crumplers. A performance of Russolo's *Gran Concerto Futurista* on April 21, 1914, the first public demonstration of these machines, was predictably met with whistling, booing, flying vegetables and violent scuffles.

It is the pattern and structure of contemporary urban life that provides the overriding subject-matter for a large number of today's artists. The cacophony of the contemporary urban, post-industrial, electronic landscape assaults the senses of us all. We face this scene everyday and we select what we need and try to make sense out of what we are left with. The streets become a sonic battlefield that pitches us towards overload. Noise rejects melodic structure along with traditional forms of rhythm and lyrical form. The notion of composition is exchanged for excess; excessive sound, excessive feeling, excessive nausea, excessive pornography, excessive pain, excessive revulsion, excessive love. Performance itself is then in turn exchanged for perception, for maximum effect, and the achievement of madness. There can be no structure and no certainty but what happens.

Russolo not only marked the beginning of noise music, his isolation of individual forms of noise also looked forward to the advent of sampling. The use of collage – as another form of sampling – has been a staple of contemporary art since the first decades of the century and following their discovery, in October 1959,

Brion Gysin and William Burroughs deployed the cut-up and fold-in techniques to reinvigorate writing so that it could now lay out a fragmented time of experience over the space of the printed page. Narrative is renounced and the authorial voice questioned so that 'nothing remains but an immense web of reading and writing, folding, unfolding and refolding indefinitely. The reading of it is no longer external to the writing.' Such an attitude to music has been a commonplace for more than a decade, since 1987 and the releases of the JAMs' *All you need is Love* or 1987: *What the Fuck Is Going On*, M/A/R/R/S's *Pump up the Volume* and Coldcut's *Beats and Pieces* – all of which created the context where pop could eat itself through its journey into sound, leave authors and composers on the shelf, and during which time *What Time Is Love?* could be repetitively re-mixed and re-released.

Many of today's artists might have grown up at the time of punk, but these artists – such as Tracey Emin, Jessica Voorsanger, Dinos & Jake Chapman, @mbassadors, Cerith Wyn Evans, Angela Bulloch, Sam Taylor-Wood, Jeremy Deller, Adam Chodzko, Tom Gidley, Gavin Turk, Jane Wilson & Louise Wilson, Georgina Starr, Milo Hennessy, Chris Ofili – matured in the environment of the late 80s and early 90s: *Don't Take Five (Take What You Want)*. The sample merges with the cover version (and the cover of a cover and so on) to become so much static that needs to be negotiated. But we love it so – 'je t'aime' (cybersex) – it still offers a chance to mess things up, or alternatively 'trash and thrash the bottom end of rock'. Beyond the sample towards systems, pure noise, or towards techno and drum 'n' bass, speed garage and beyond, content is meaningless without effect – without the ecstatic dancefloor (the perception). Artists have always wanted to break down the walls of the gallery and play with the politics of chaos that simmer within the structures of a theatre of mass-entertainment. Where is love in *Fuck the Millennium?* Striking Liverpool dockers, the Williams Fairey Brass Band, the Red Army Choir and a 19th-century RNLI choir together provide a backdrop for the projection of a clear image of struggle through the form of an, almost out of control, agitational propaganda; we want it now. A struggle of love for a world to change amid urgent questioning or, again, a media event.

Love can be harsh, a beautiful thing to be experienced, but it rarely turns out like the movies or the big musical production number which seems just pure comic book – it's time to fall, can't you hear cupid's call. (Wish that it were like that, sometimes.) Love is not necessarily sweet, but can be danger and turn into obsession and delusion. Now it is possible to know people without ever meeting them. And then there are the stalkers... I think about you all the time. I watch you from afar. I like driving in your car. I've got your ex-directory number. I know where you live. I've got the keys to your flat. Hahahahaha.

Among all this televisual computer-bred soap-opera bpm life, what else is this but a cd with a price tag? All this talk – content, meaning, excess, life, subject-matter, desire, love, perception, madness, culture, revolution, pornography, vision, re-invention, experience, process, reality, liberation, playground, sensation, struggle – is but a construct; it is all artificial. There are other words here too, words like restriction, oppression, manipulation, theatre, representation, mediatisation, commodification, mediation. Just remember: Real Life Is Elsewhere.

© Andrew Wilson, 1998

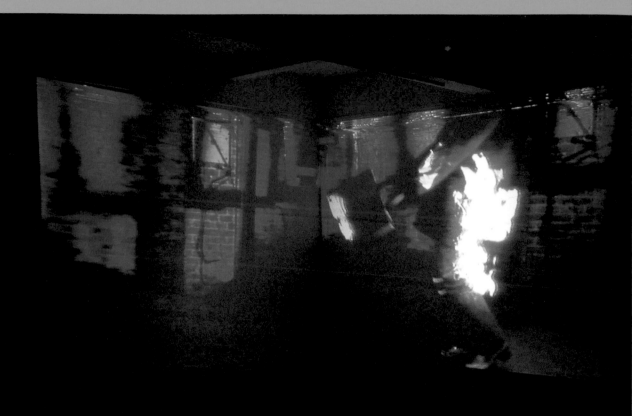

'Normapaths' • Jane & Lousie Wilson *1995. Detail, 16mm film (2 U-matic, 3 mins 40 sec loop) projection of 335 x 427 cm Film set: 244 x 488 x 488 cm.*

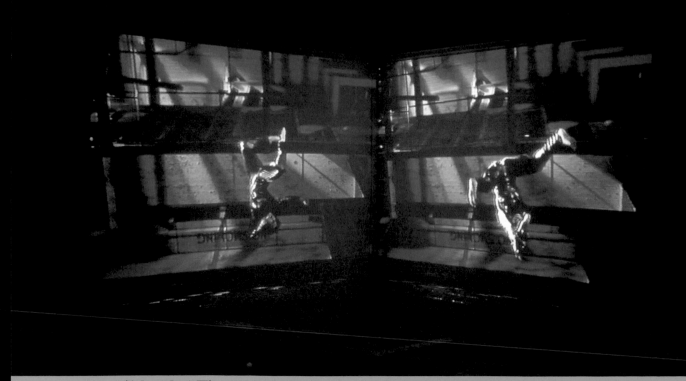

'Normapaths' • Jane & Lousie Wilson *1995. Detail, 16mm film (2 U-matic, 3 mins 40 sec loop) projection of 335 x 427 cm Film set: 244 x 488 x 488 cm.*

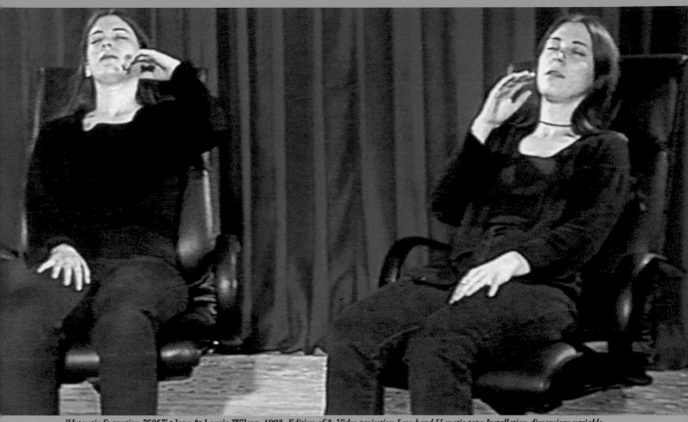

'Hypnotic Suggestion "505"' • Jane & Lousie Wilson *1993. Edition of 3. Video projection Low band U-matic tape Installation dimensions variable.*

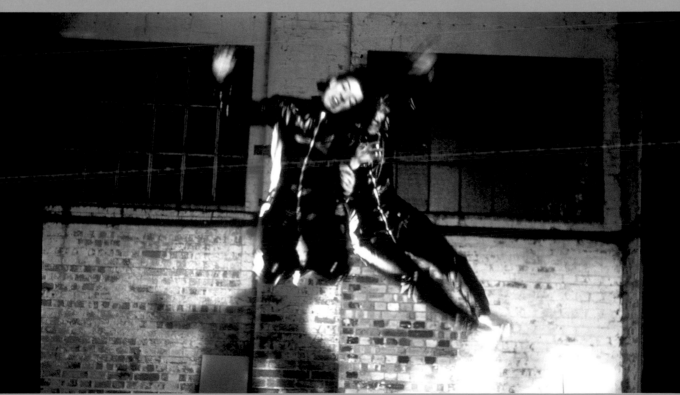

'Normapaths' • Jane & Lousie Wilson *1995. Detail, 16mm film (2 U-matic, 3 mins 40 sec loop) projection of 335 x 427 cm Film set: 244 x 488 x 488 cm.*

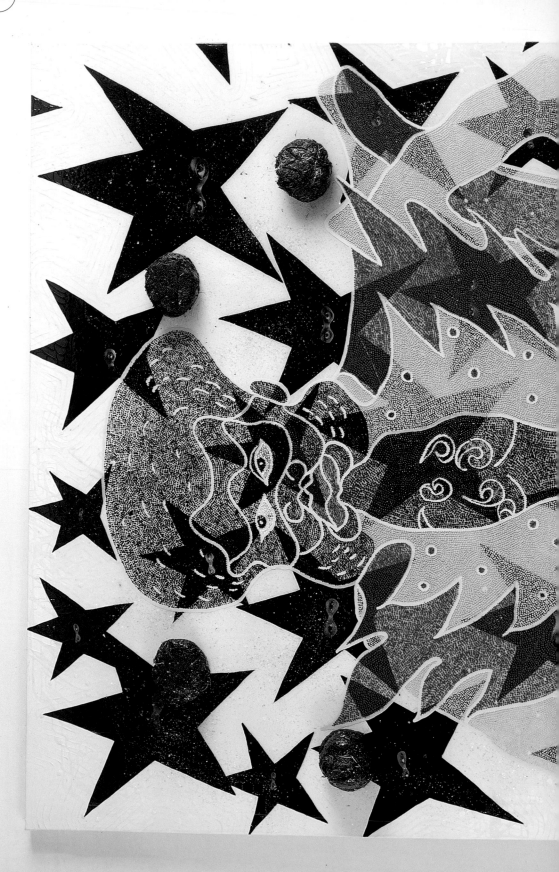

'The Adoration of Captain Shit and the Legend of the Black Stars' • Chris OFILI *1998, 8ft x 6ft, acrylic, oil, resin, paper collage, glitter map pins & elephant dung on ce*

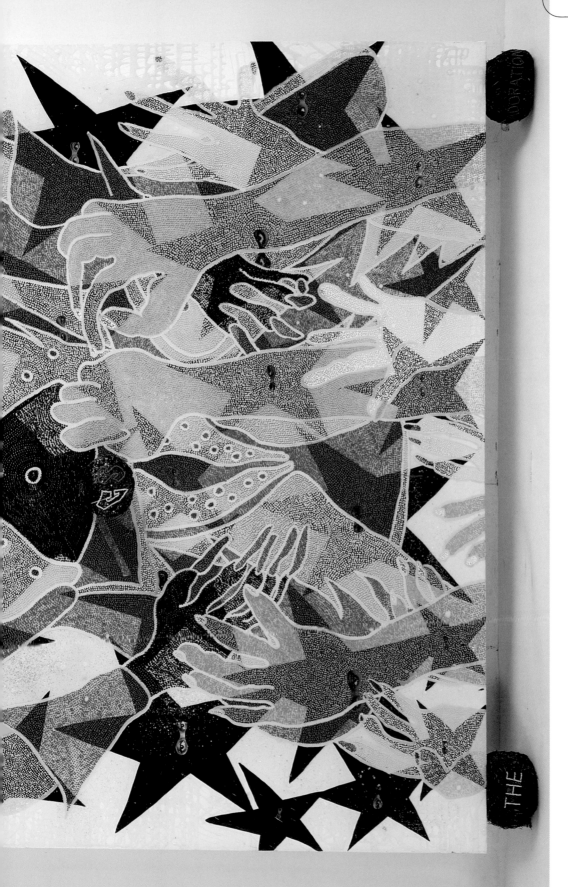

5th Fret of any string =
the next higher open string.

ie. 5th fret on low E string =
(1st dot)

A , same as the next higher
string E.

Double dot on any
string = octave
higher than
the open string.

F
F#
G
G#
A
A#
B
C
C#
D
D#
E
F

G
D
A
E

Big Bottom

Susan Stenger
~~Electric bass~~

Angela Bulloch
~~Electric bass~~

Cerith Wyn Evans
~~Electric bass~~

Tom Gidley
~~Electric bass~~

J. Mitch Flacko
~~Electric bass~~

HOW TO GET IN TOUCH WITH THE @MBASSADORS

It's easy to get in touch with the @mbassadors! So says a leading expert who adds that the @mbassadors are eager to give you a helping hand. 'There are no exceptions- every one can communicate with the @mbassadors, " Dr. Hufhufhurrr, PhD told MODERN ARTISTS .

The son of the first recorded alien abductee, Dr. Hufhufhurrr holds a doctoral degree in counselling psychology with particular reference to "artists" and is the author of "Artists On The Couch".

He conducts seminars to help artists "get in touch". Here is his advice:

"THE FIRST STEP in communicating with the @mbassadors is simply the desire to do so," says expert Dr. Hufhufhurrr.

You don't need a formal invitation or ritual to call on them. You don't even need to verbalise your call.

To begin communicating with the @mbassadors, it is helpful to relax your MIND.

Look out of the tower block. Appreciate modernity, such as a car, street light or advertising billboard. Focus your MIND on the miracle of industrialisation. Another way to quiet your MIND is to take two or three slow deep breaths. or watch the commercials on TV skilfully avoiding all programme breaks

It's easier to see the @mbassadors when you are alone and in an urban setting. Make a daily appointment to spend some time by yourself when your MIND isn't focused on daily survival.

Although just thinking of the @mbassadors will frequently put you in touch with them, there are ways that may work better for you.

YOU CAN WRITE a letter to the @mbassadors. Pour out your heart, hold nothing back.

YOU CAN also try visualization. Use your imagination- visualise the @mbassadors flying in circles around you. THINK, '@mbassadors, please help me'. If you are sincere they will hear your call for assistance.

YOU CAN also speak aloud and the @mbassadors will respond. "

Dr Hufhufhurrr said there are a number of ways you can tell when the @mbassadors are near. You might feel their presence such as a hard slap across your face, a knee in the groin, a burn on your arm like fire.

"You might also see a sudden flash of an erect penis or the open fascination of a woman's legs out of the corner of your eye."

He also added, "You could also hear a strong statement in your ear that urges you to improve you life - or warns you of banality.

Once in the presence of the @mbassadors, ask for the assistance you need. Your call for help is sweet music to an @mbassador's MIND.

Investors can ask for @mbassador security systems to guide & protect their savings. If you are poor ask the @mbassadors for the security codes," said Dr. Hufhufhurrr.

"If you ask for advice, an @mbassador may answer with a voice that seems to be part of your imagination. Pay attention to the suggestions when these thoughts come into your head, also high pitched tones or buzzing in the mind warn of imminent abduction.

@mbassadors also offer guidance by planting symbolic images in your mind. If the image of a green light pops into your head, an @mbassador may be advising you to speed up.

Sometimes you'll be looking for a solution to a problem when suddenly a crystal-clear answer lights up in your MIND - another sign of the @mbassadors at work!"

ARE YOU
TEMPTED?

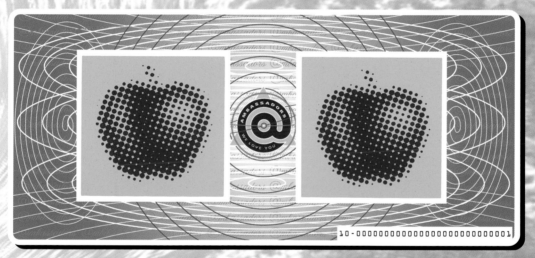

REMOVE WITH THE UTMOST DEGREE OF CARE

VOID if both removed

Hide, dark ambassador,

Beneath your flowers of blood,

The virginal ring opened

to the matador's blade.

Jean Cocteau